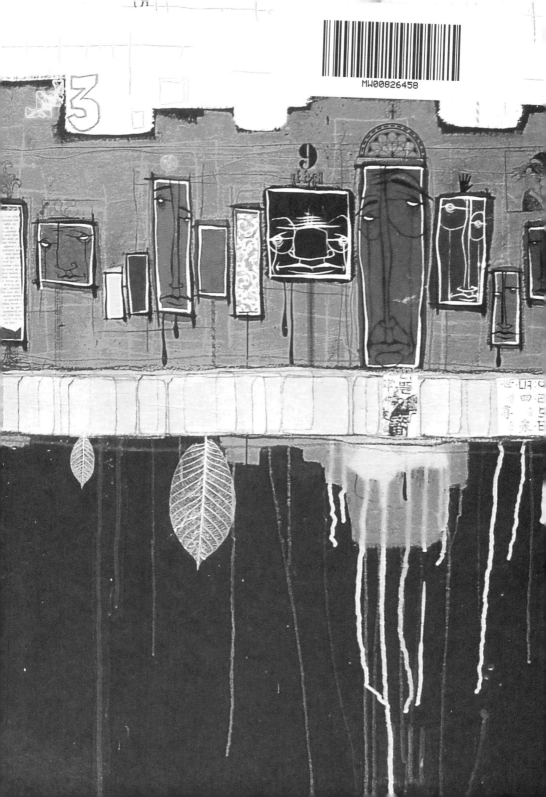

SAHIB,

Congratulations on your recent graduation!!
I hope this book brings a little inspiration
in your life.

Blaine

BLAINE FONTANA
"SEDIMENTAL PROMISES"
a retrospective 2002-2006

PAINTINGS BY BLAINE FONTANA
www.blainefontana.com

BOOK DESIGN & LAYOUT
blaine fontana

SEDIMENTAL PROMISES

THE ART OF **BLAINE FONTANA**

TABLE
OF CONTENTS

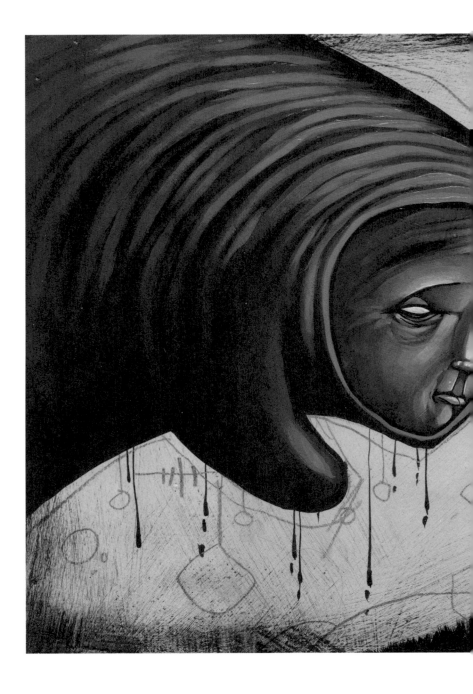

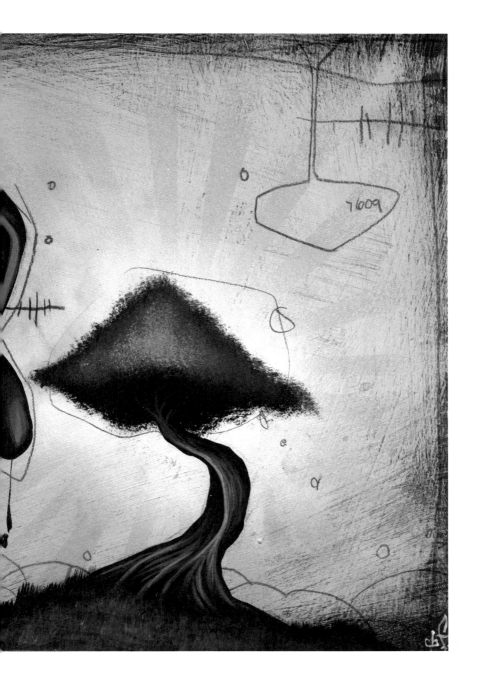

PROLOGUE

When I think of nature present in the world of art I immediately think of Blaine Fontana's humming birds fluttering their energetic wings about his gourd birdhouses. Blaine's work is bursting with nature's elements, animals, insects, fish, rooted landscapes and his signature half-creature/half-human characters he has labeled as "Templings". These androgynous "Templings" are an integral part of Blaine's paintings. He sees them as his gatekeepers to the mythical world of nature he portrays throughout his work. Deriving the word "Templing" from the union of two words; temple and beings, these signature Blaine characters are seen by him as demigods - human in spirit and a mask of emotion. Each figure is represented differently to guard over his magestical world filled with nature.

Looking at Blaine's work you can almost imagine yourself transformed into his explosive compositions. They are vibrant and full of the tiniest technical details that probably go unnoticed on first viewing. Taking a closer look, you'll find a unique blend of textural patterned backgrounds. These organic backdrops take on several influential forms pulling from various world cultures. For his Asian themes, Blaine pulls from Asian folklore depicted though the use of obscure montages of Asian calligraphy, forna and sometimes found objects. These textural backgrounds are often an ongoing process as he builds up the many different layers to arrive at a completed composition that blends his two worlds together to depict a vibrant abstract story for his contemporized hieroglyphics.

Blaine's background, much like his artwork, is a montage of urban and natural influences. He grew up in an artistic community on a private island just west of Seattle. From a very young age, he was encouraged to be creative by his mother - who also shares a passion for the arts. Blaine went on to pursue his studies in commercial art and design. In 2002 he graduated from Otis College of Art and Design with a BFA in Communication Art and Design at the top of his class with the "Best in Show" award. The skills he developed though producing graffiti were not all together abandoned while he pursued a graphic design career. The speed and intuitiveness of Graff still play a large role in his work. During the construction of a painting he'll utilize those skills to completely cover up a weeks worth of work without a moments hesitation. He also utilizes the vibrant palette of colors associated with the world of graffiti.

It is these multiple elements, borrowed from a spectrum of influences, and ridden with textural detail that I find fascinating about Blaine's work. This interest led me to inquire deeper into who he is and how he formulates these works of art. Luckily I've had the good fortune to get to know Blaine over the past four years, and rather than list all of the many (and I mean many) accolades, clients and goals he has already achieved in the art world, I'm going to tell you about a shared experience. This experience gave me closer insight into how this energetic man thinks, and what makes up his eclectic personality. It's clearly portrayed in the fluttering winds of his humming birds and the enematic faces of his 'Templings'.

Like most creative ideas, they start with a tiny thought seed. This one started in my living room during a visit by Blaine and his girlfriend, Eugenie. While looking at the paintings hanging on my walls, they commented on the fact that most of them depicted either birds or rabbits. This was something I had not really noticed up until that point. Conversation that evening continued along that theme. We wondered how many artists actually paint birds in their work. We began to create a list and soon, I'm not quite sure exactly how, it developed into an idea for an exhibition. 'The Birdhouse Exhibition' came to fruition in December of 2005 when it opened to a phenomenal response. Basically, in a nutshell, the idea of 'The Birdhouse Exhibition' was this - imagine if you were a human-sized bird living in an urban environment. What would your house be made up of? Discarded window frames, broken wardrobes, front doors, broken or cut down tree branches, etc. What pictures would cover your living room walls? Surely they'd be pictures of your bird friends.

8.

So the seed was planted in Blaine's head, and it was not long before he was sending me links to relevant websites. One hosted imaginative birdhouse floor plans and their living room installation ideas - right down to suggested material to wallpaper the walls with. Then during a casual meeting to discus the construction and positioning of the actual birdhouse in the gallery, I was blown away when Blaine turned up with a mixture model of the actual birdhouse. He had clearly taken a lot of care in its paper construction, adding tiny details of twigs stuck onto its roofing to replicate tree branches protruding though the rooftop of the house they were about to build.

Blaine's dedication was not to stop there, the day we were to construct the life-size bird house in the gallery, Blaine turned up with not just one pick-up truck (filled to the brim with collected flotsam) he also had a massive U-Haul truck (the type you'd move your whole house across country in) filled to the top. Previously to this, I had suggested to Blaine that if he started to collect some discarded wood we could place it on the side of the house and then paint on it. I had no idea that Blaine would turn up with a years supply of; old flaky wooden doors, cabinets drawers, a series of multi-faded old window frames, countertops, elaborate cabinet carvings, unusual door knockers still attached to partial doors, and more. When he opened up the back of this huge truck I almost fell backwards. It really (and this is no exaggeration) was packed to the ceiling (each piece laying flat on top of another piece) with junk. But to Blaine this was not junk! To him this was his selection of materials that he could then specifically select the perfect items from to form his installation. It took four of us hours to unload the truck and pile up all the wood. Blaine's manic enthusiasm made it tick by and soon the construction on the birdhouse was completed. Next I got to witness this maestro create around him a whirlwind of paint and chaos as he brought in, and set up, a studio desk, chair, household paint tins, four boxes filled with little craft items like mini replicated bird nests, several art supply containers filled with an array of brushes and strange mark making utensils, stencils, wooden printing blocks.... quite frankly what looked like his whole studio! I am very meticulous in how I run my gallery and pride myself on its pristine presentation, but I couldn't help be swept into Blaine's creative process. All of these things and materials when combined and utilized in the hands of Blaine managed to perfectly complement each other, much like the two juxtaposed parts of Blaine's personality.

He is a warm, friendly, generous and genuine man who loves his dog and being surrounded by the elements of nature, yet he also retains the complexity of his urban influences. I'm honored to call him my friend, and I'm excited to see how his work and skills as an artist continue to develop.

- Freddi C / August, 2006

Freddi C is originally from London, England but has made Los Angeles her home for the past seven years. Before moving to L.A., she lived in NYC for eight years, where she worked as an art director for a textile design company. It was in New York that she also started painting. After exhibiting in NYC, she took a break from painting completely and moved to Los Angeles. In August 1999 she started painting a series of paintings entitled 'Flyer Miles'. Following the success of this series, she has been working full-time as an artist, graphic designer and curator - founding 'STREETWISE'. In 2003 she opened her own gallery in Los Angeles - The Lab 101 Gallery. For more information please visit:

www.freddic.com
www.thelab101.com
www.streetwise3.com.

2002 2003

A TEMPLING
IS BORN

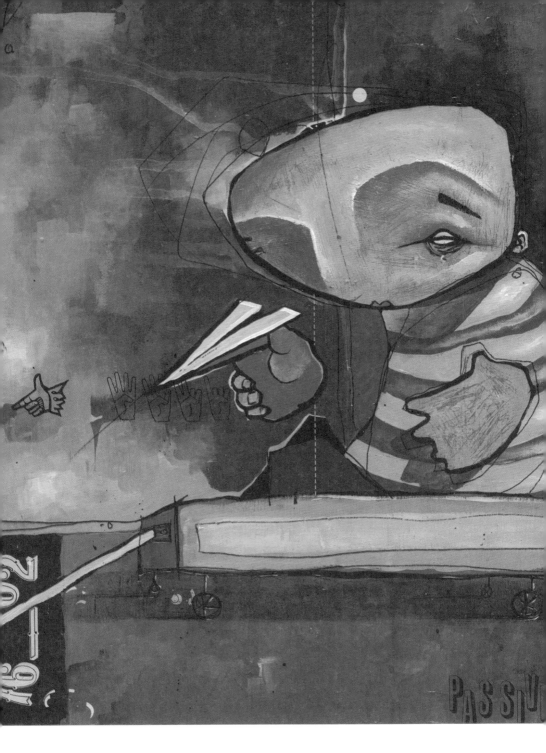

11.

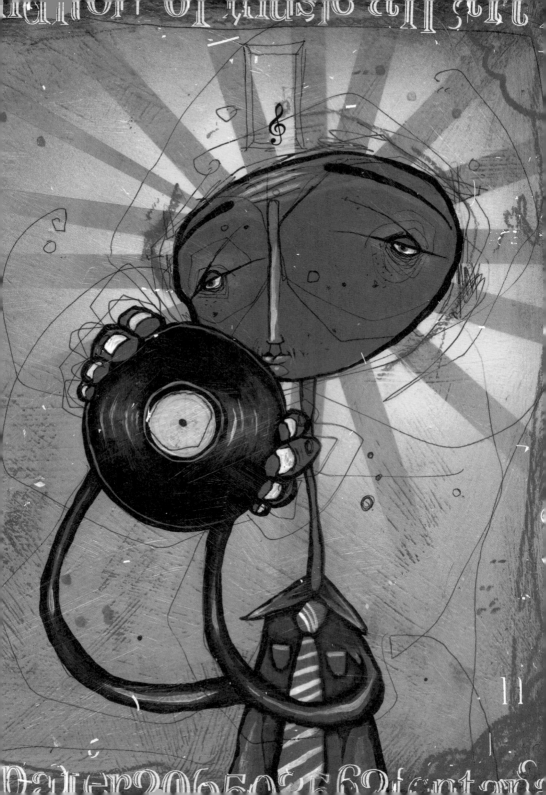

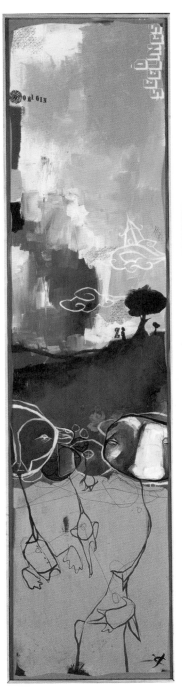
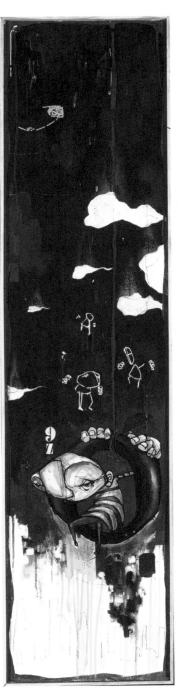

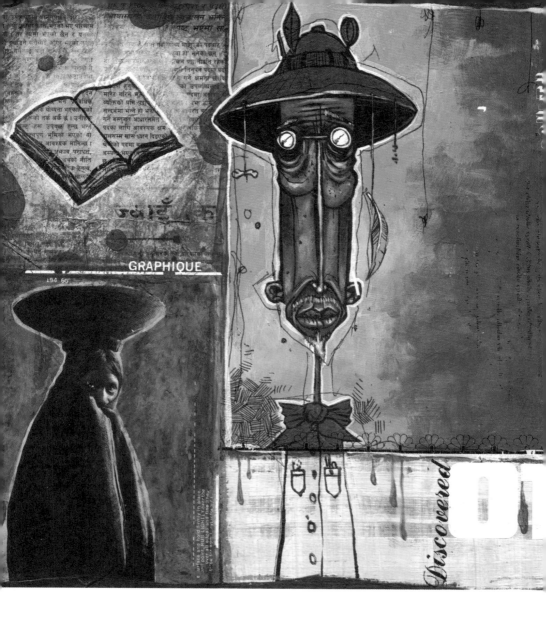

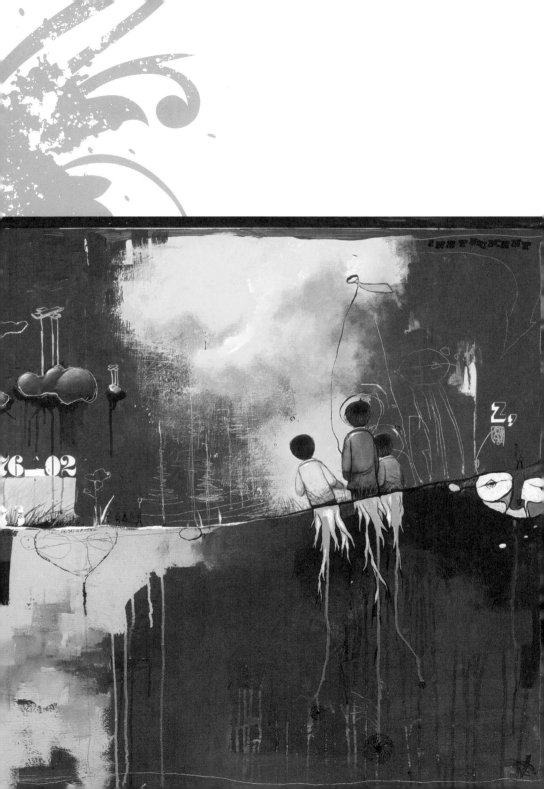

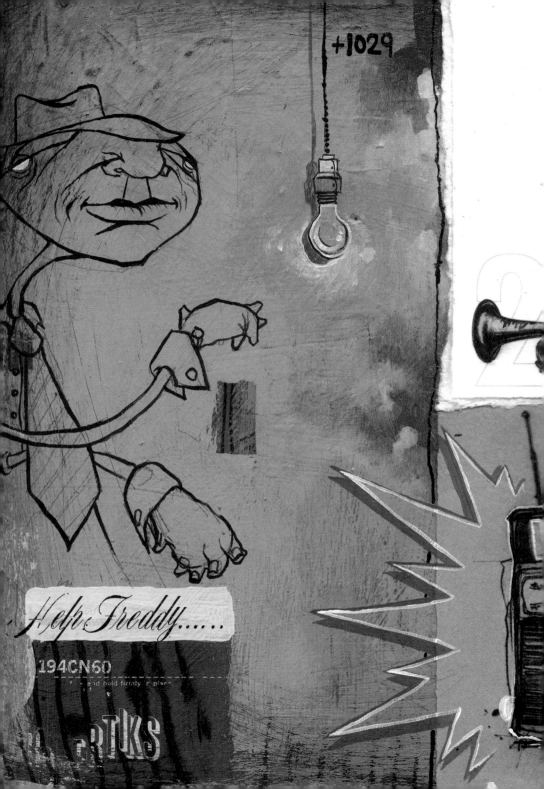

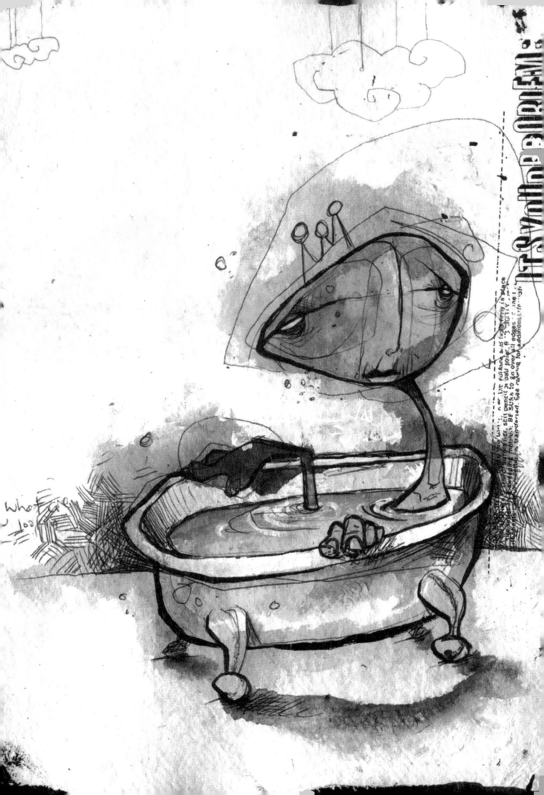

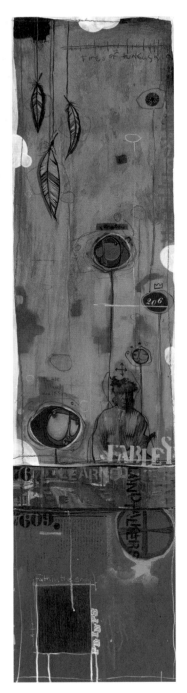
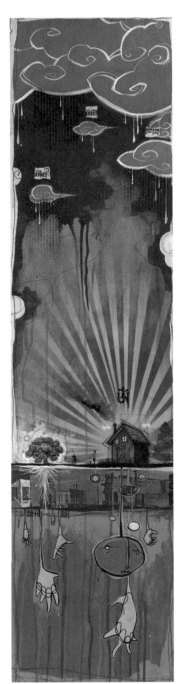
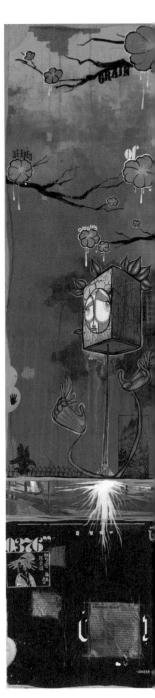

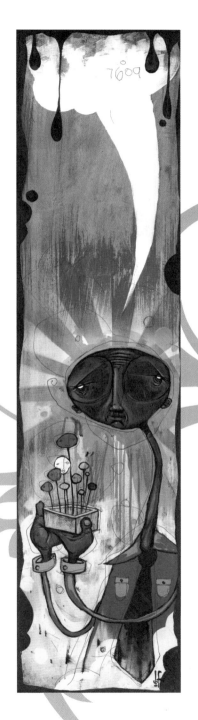
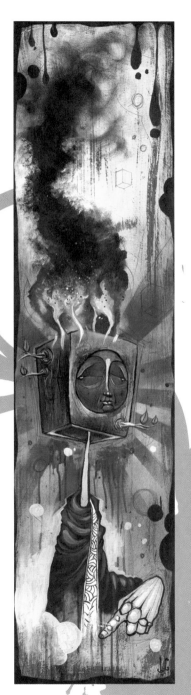

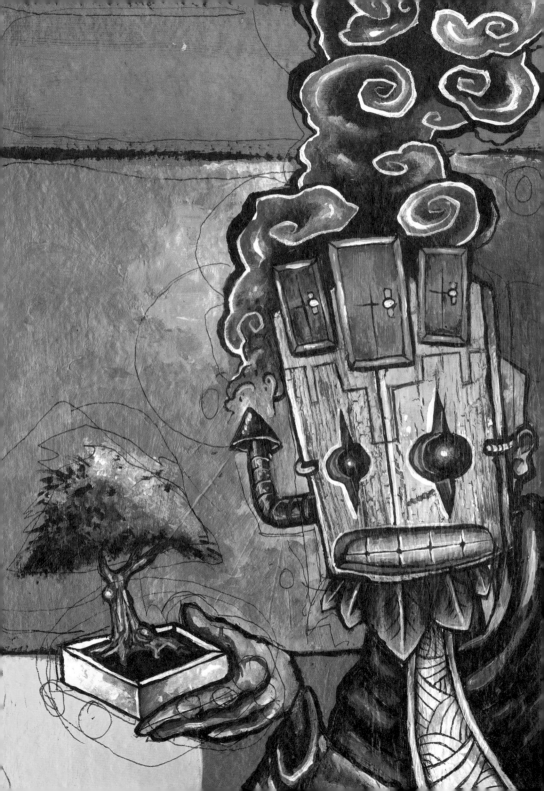

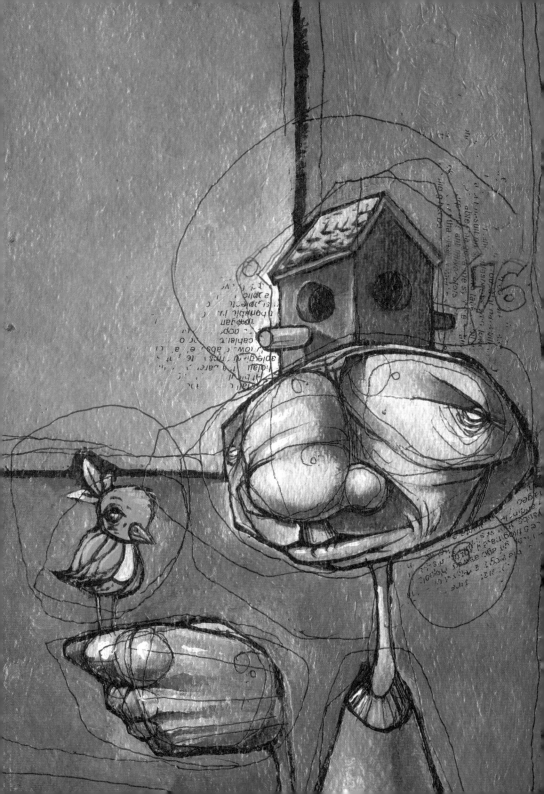

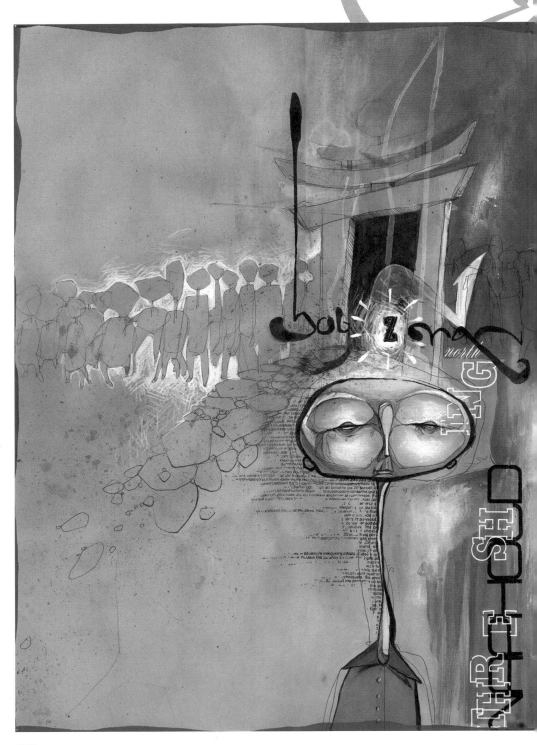

22.

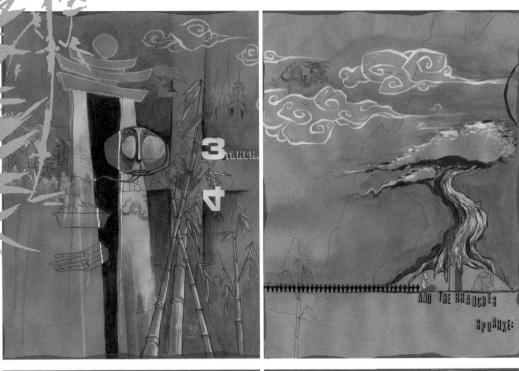

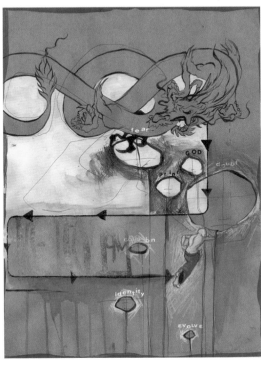

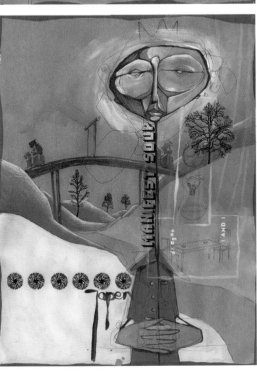

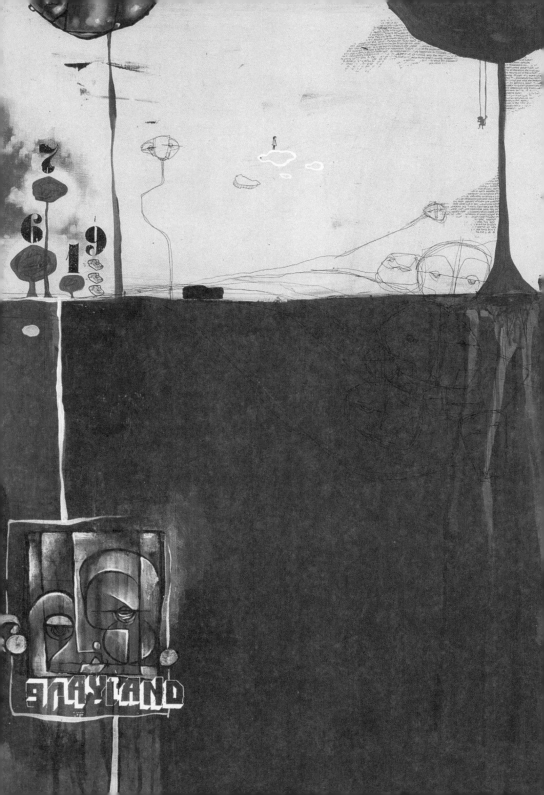

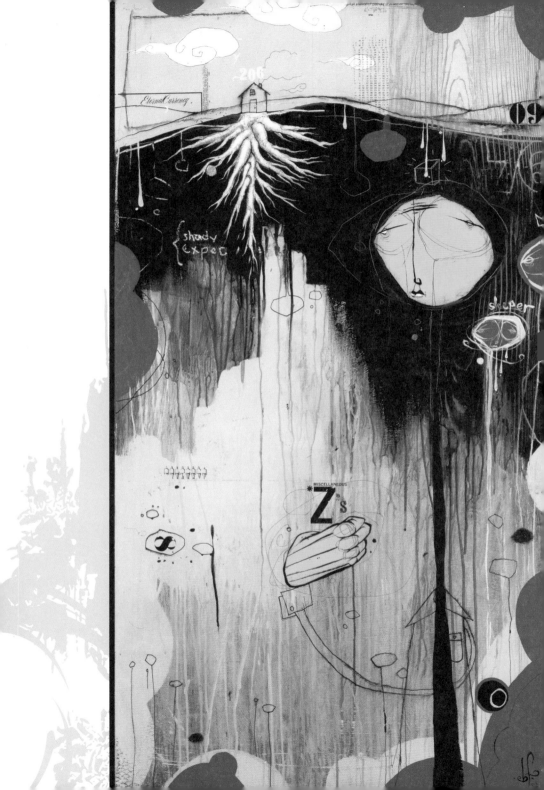

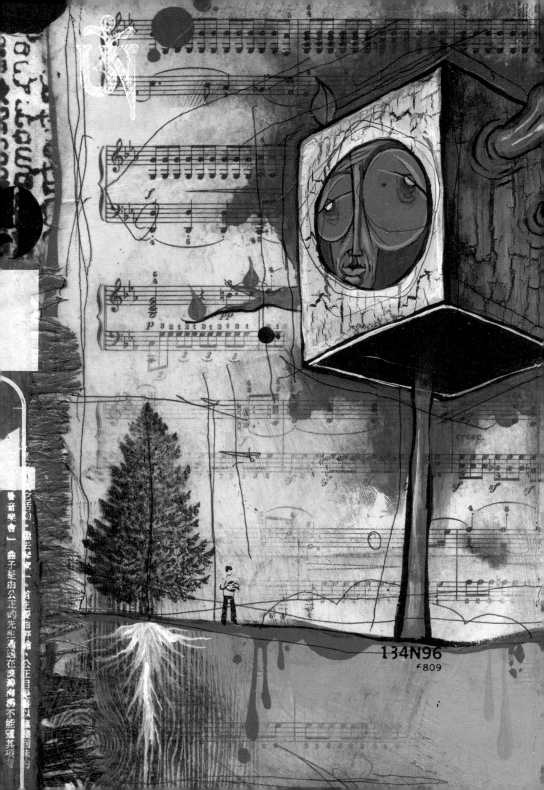

IN MY HOUSE

2004

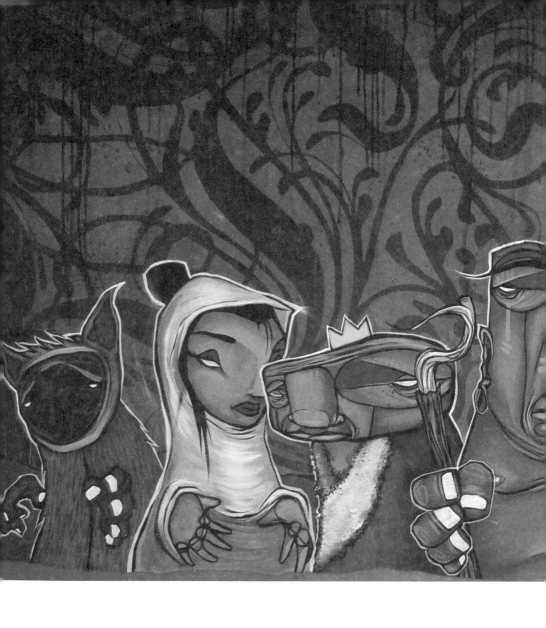

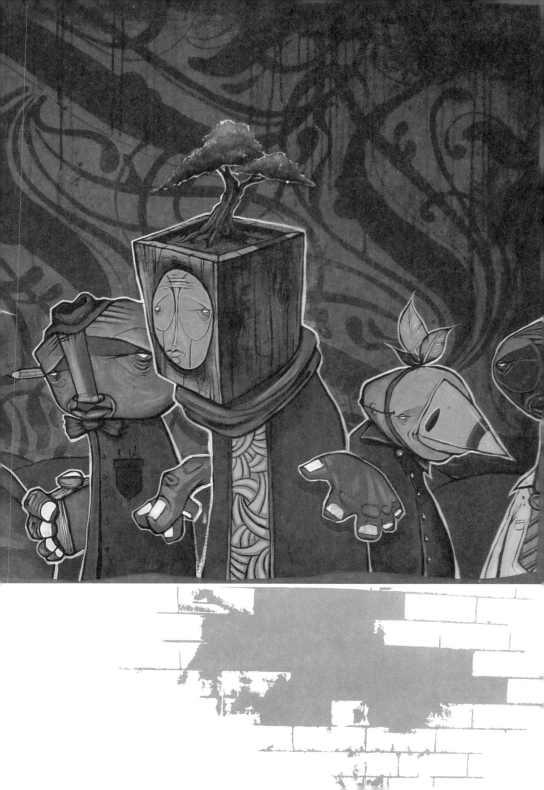

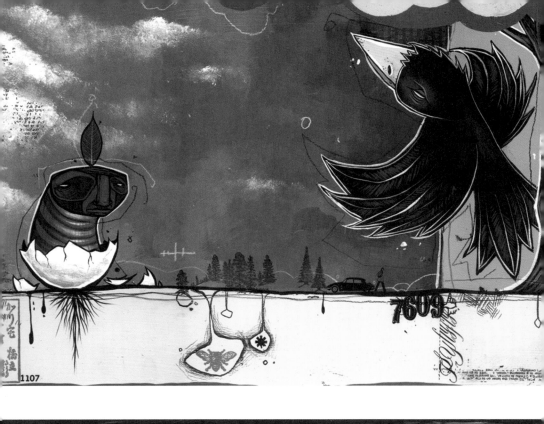

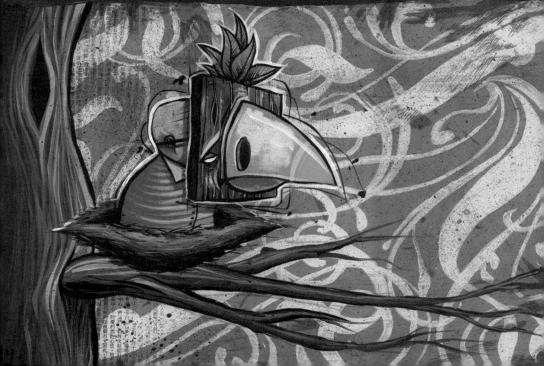

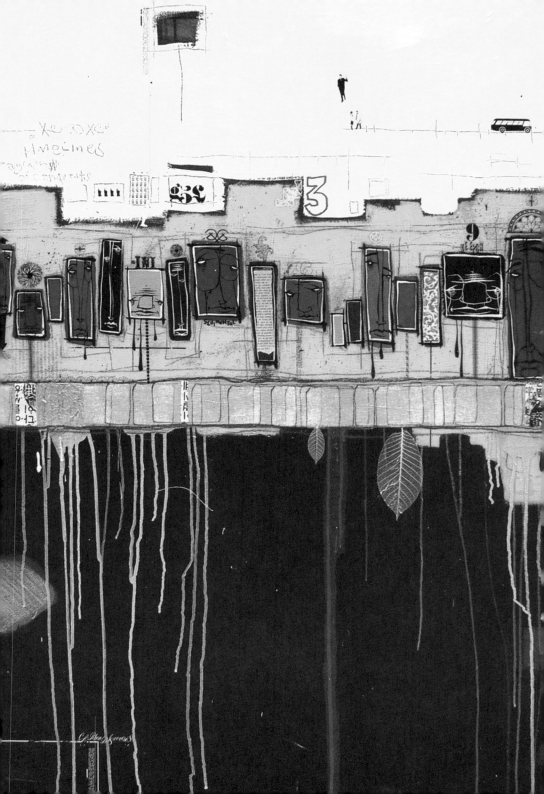

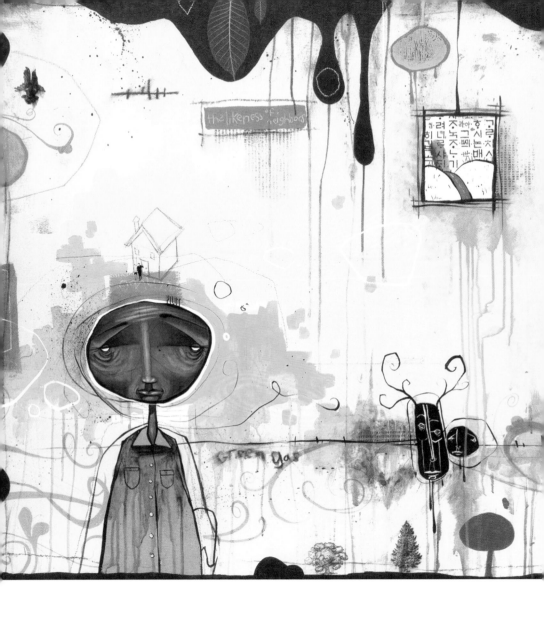

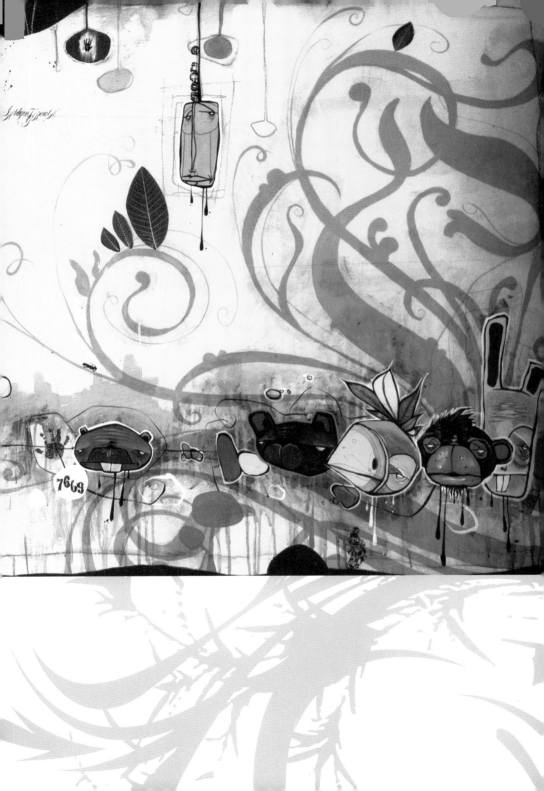

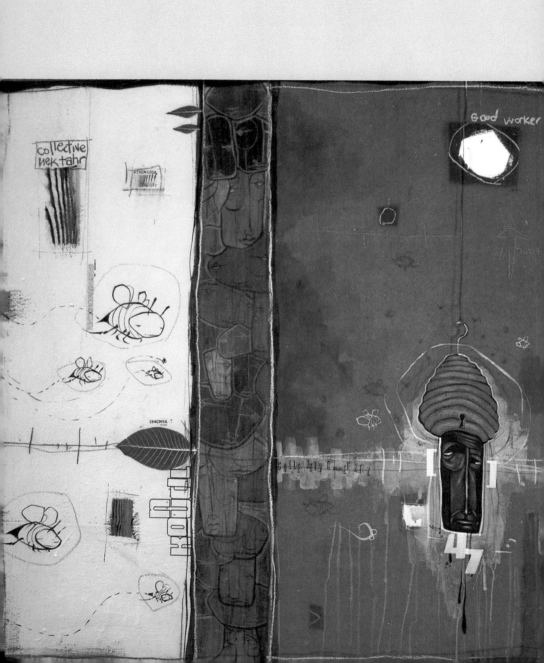

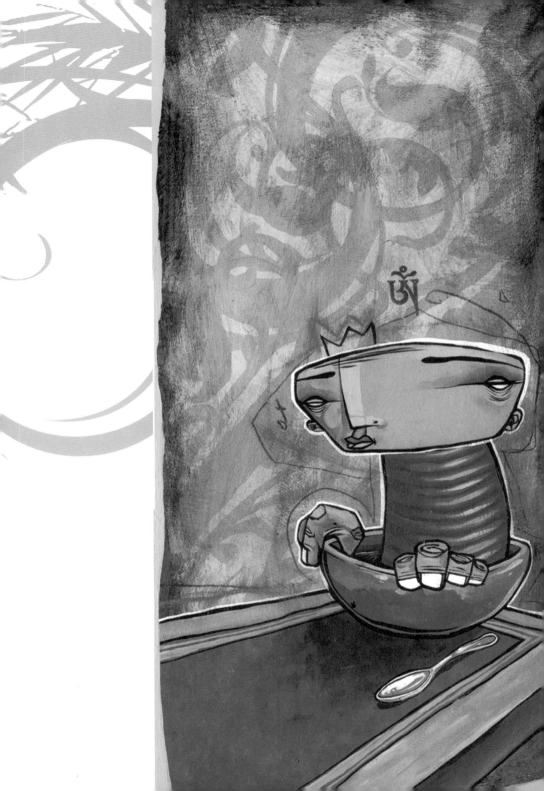

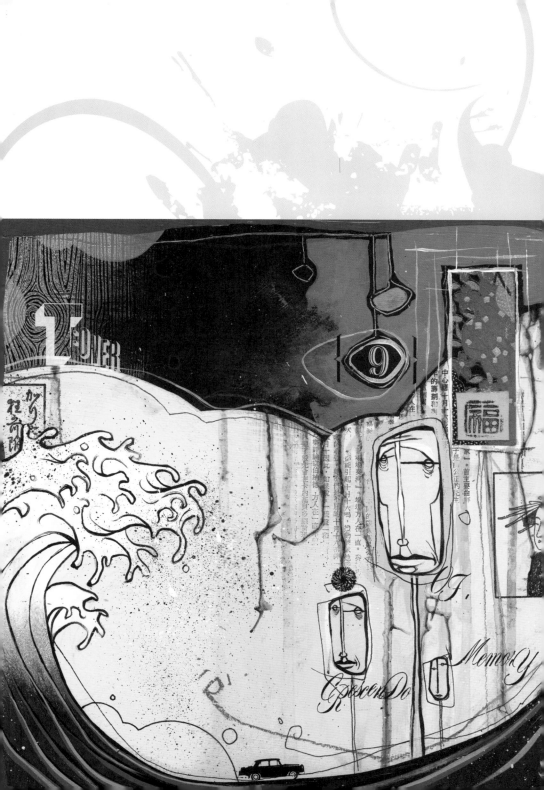

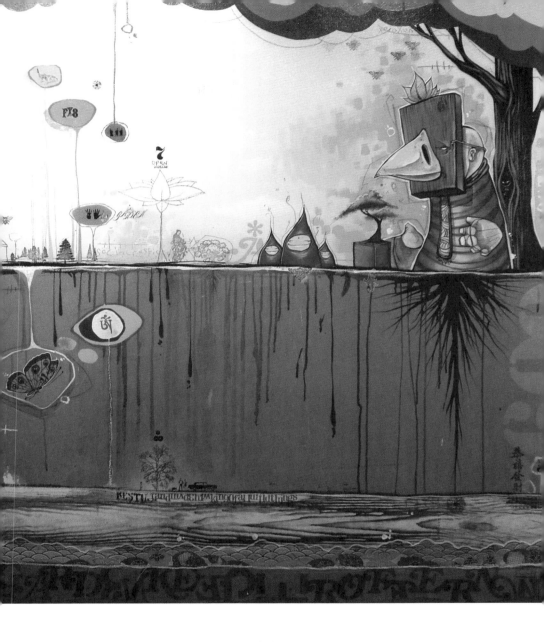

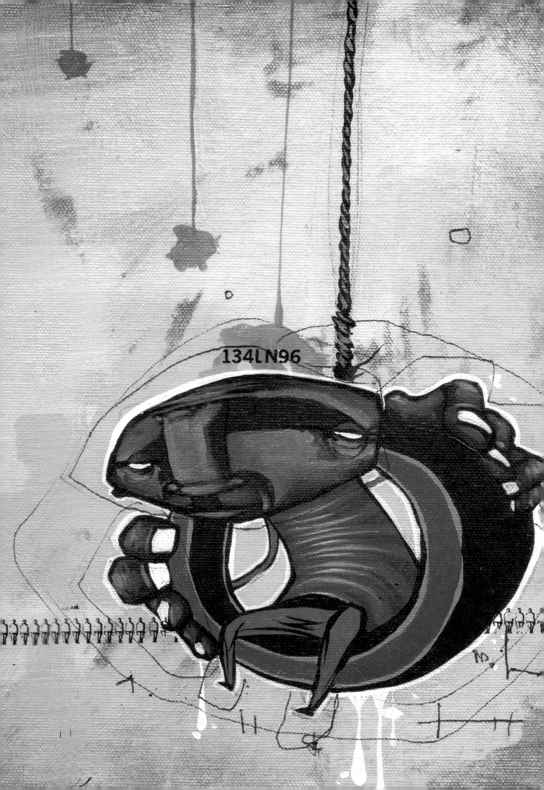

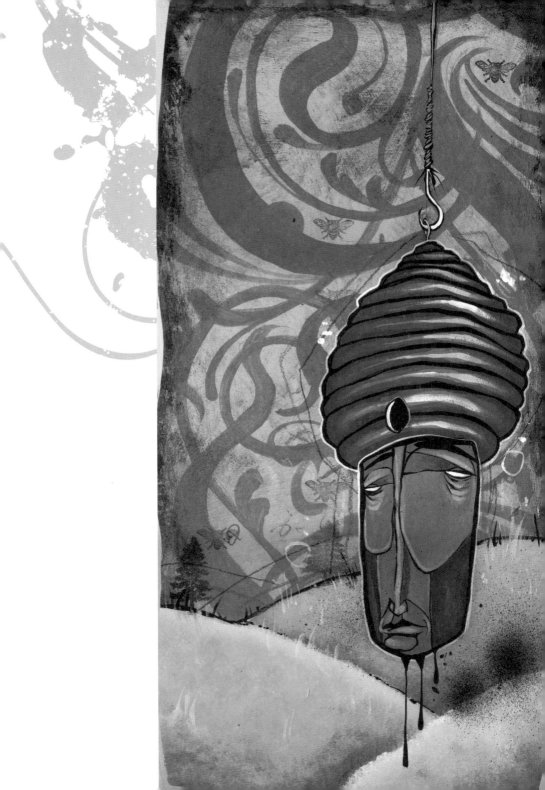

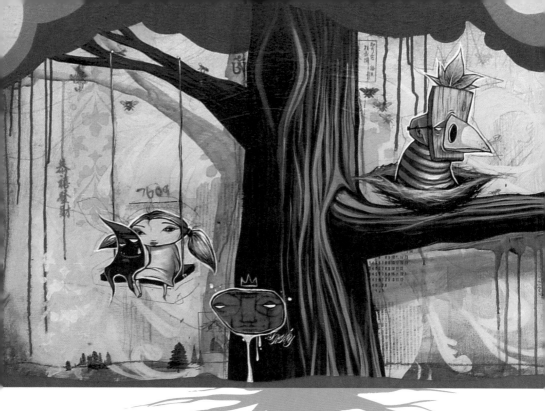

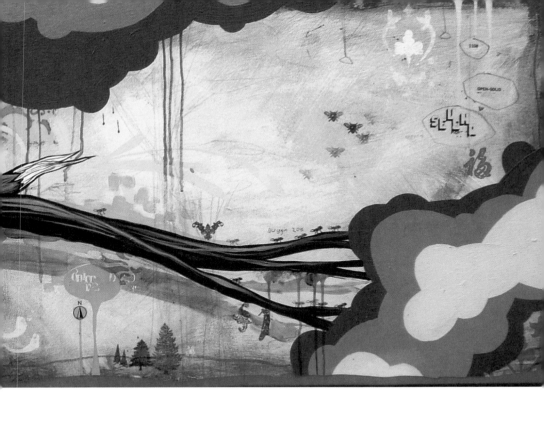

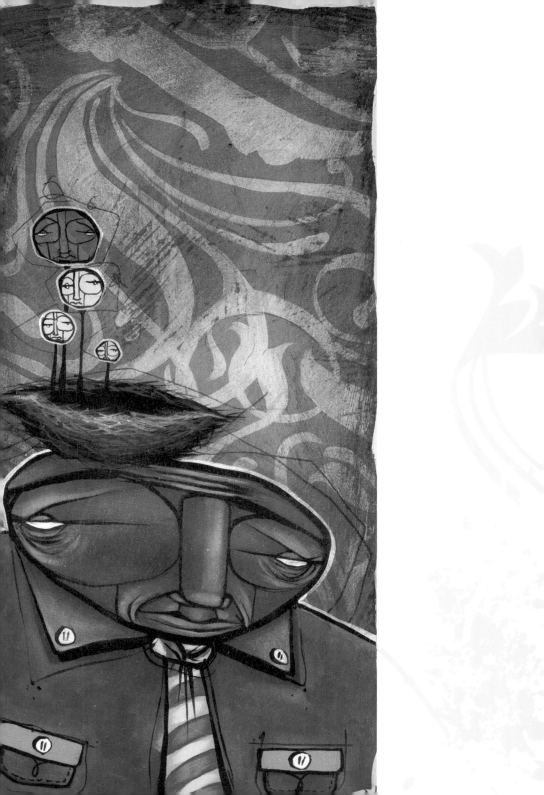

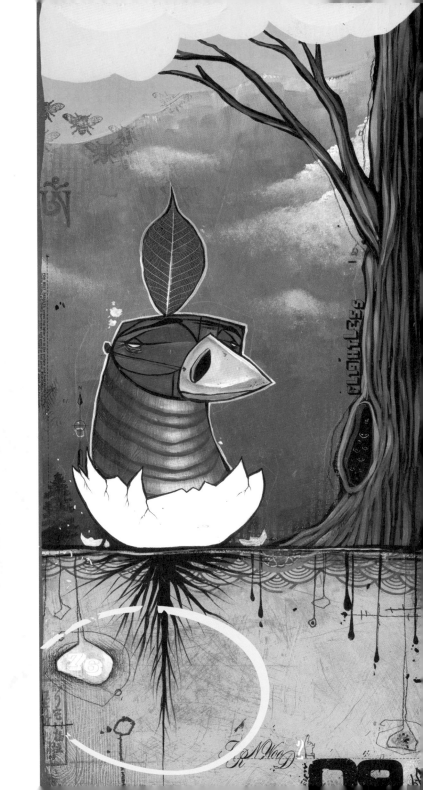

return to render

2005

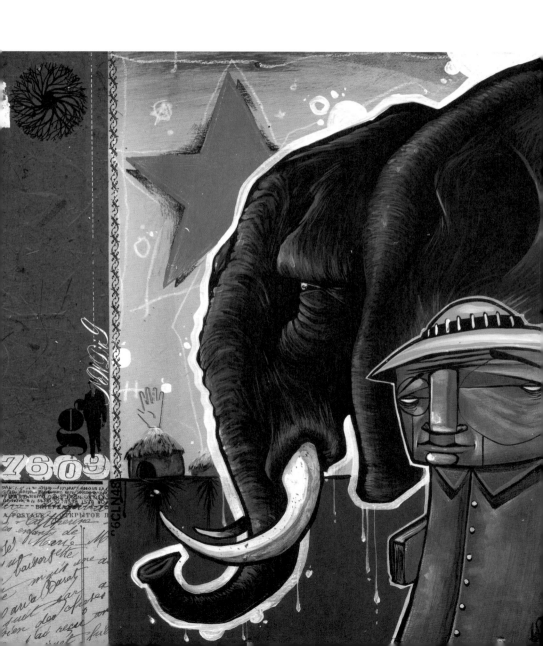

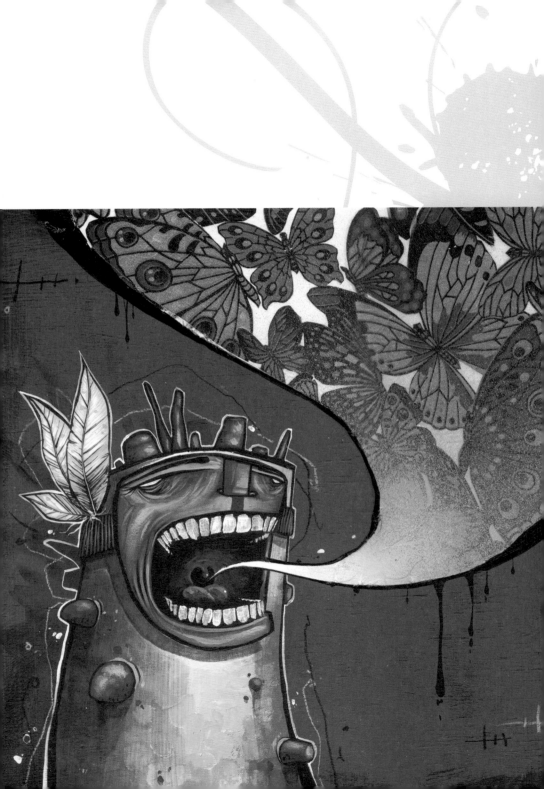

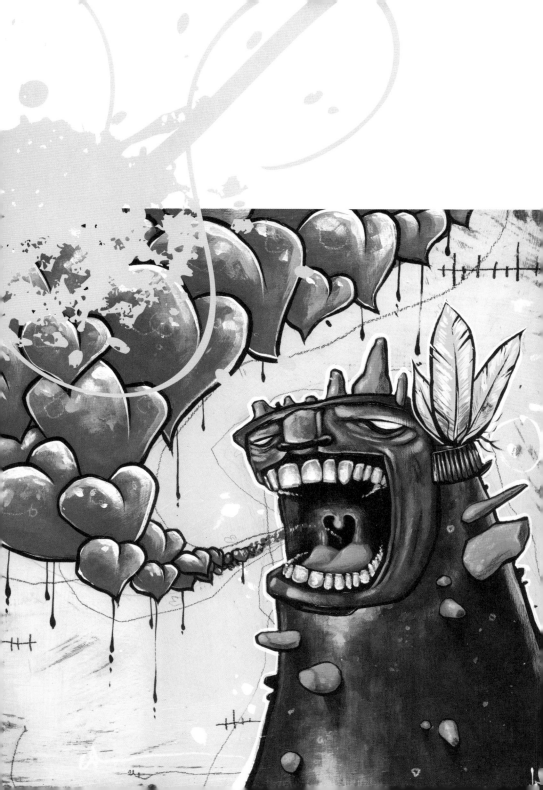

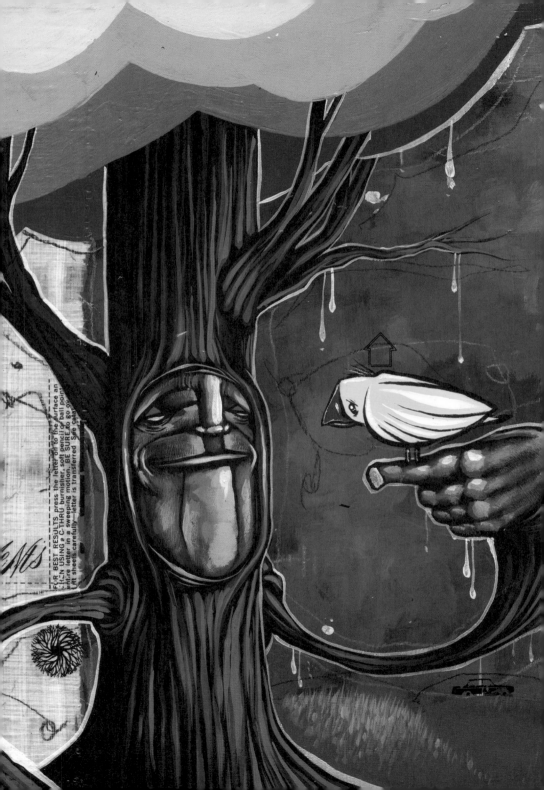

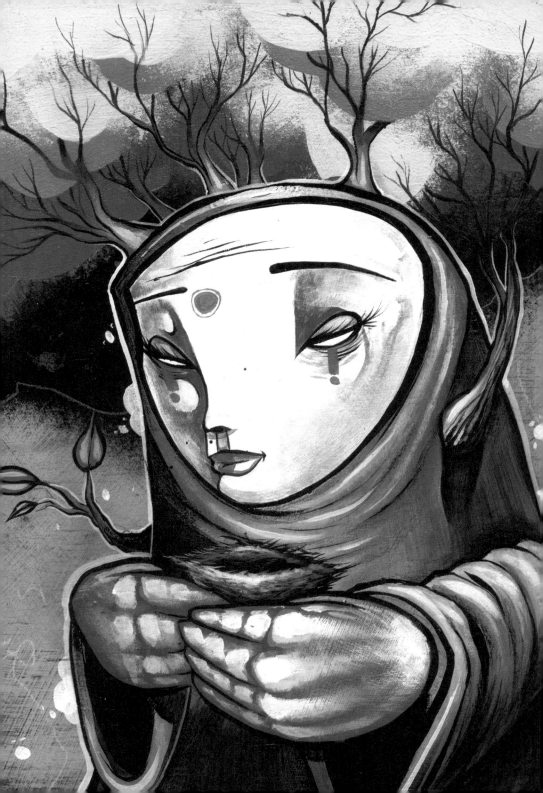

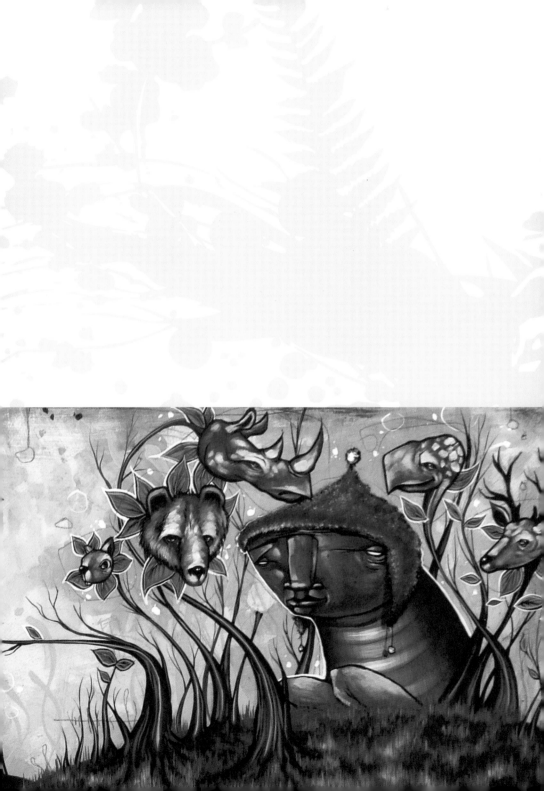

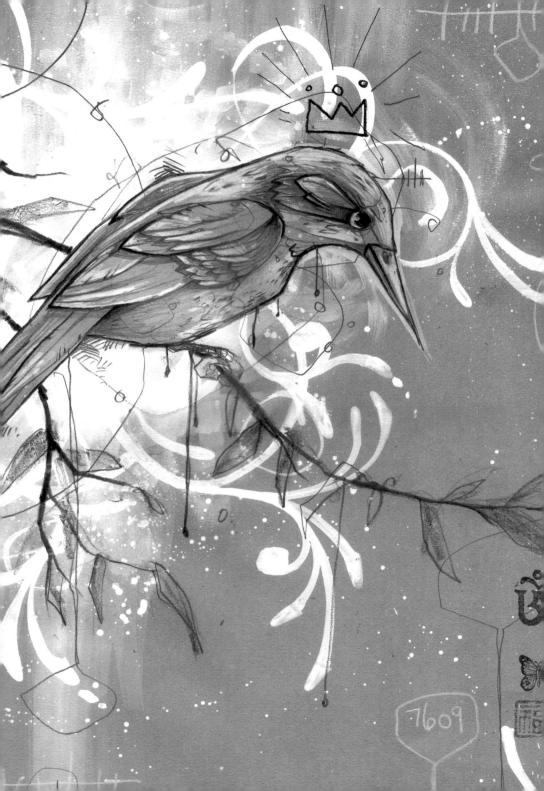

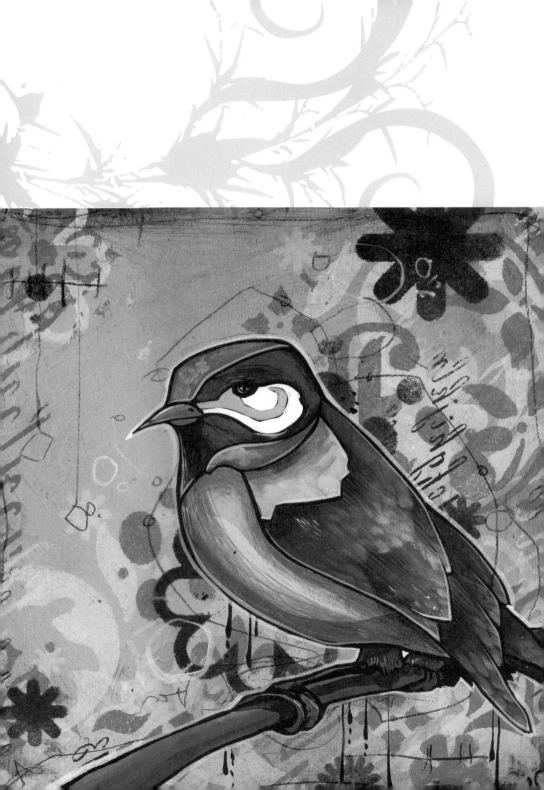

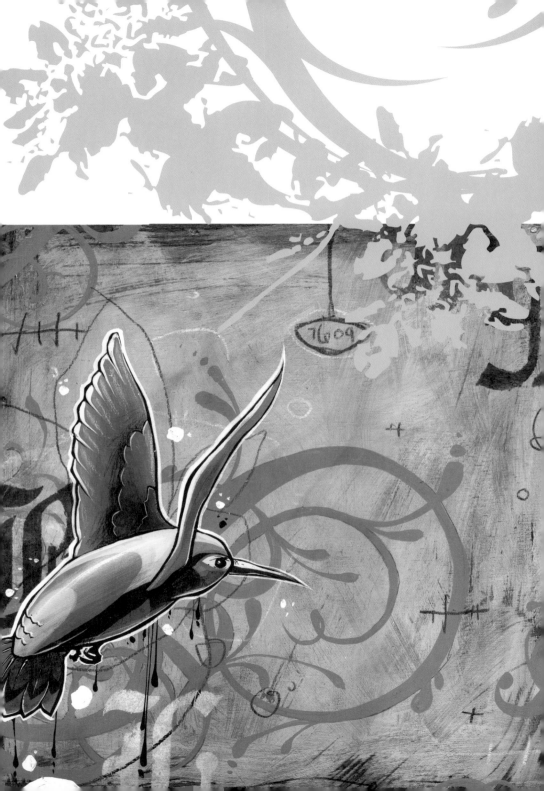

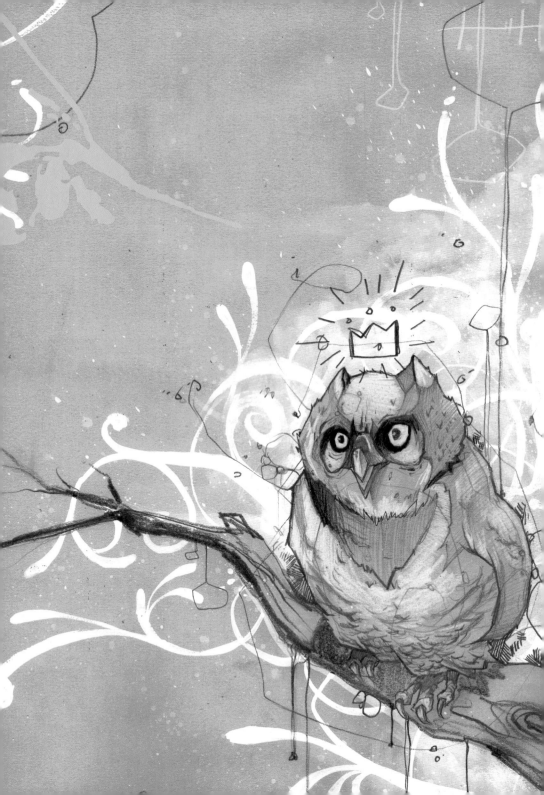

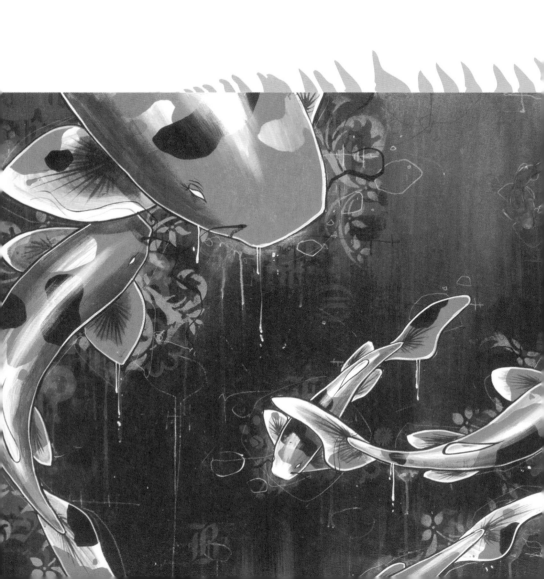

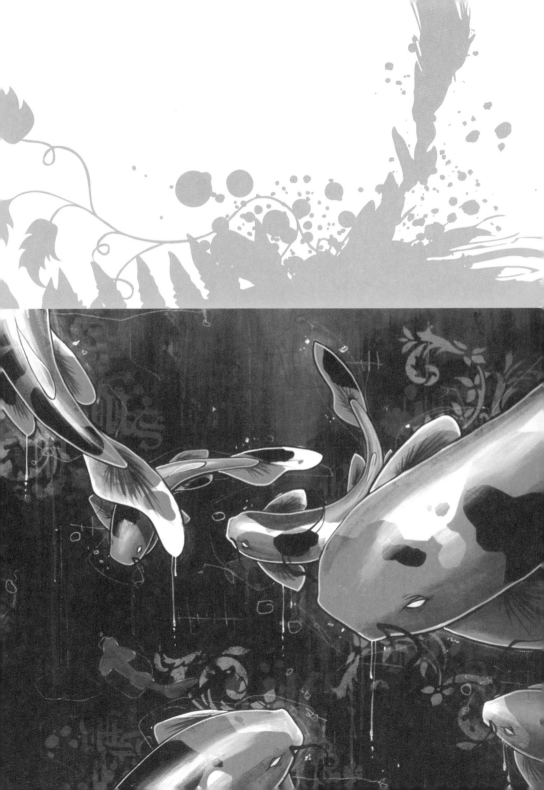

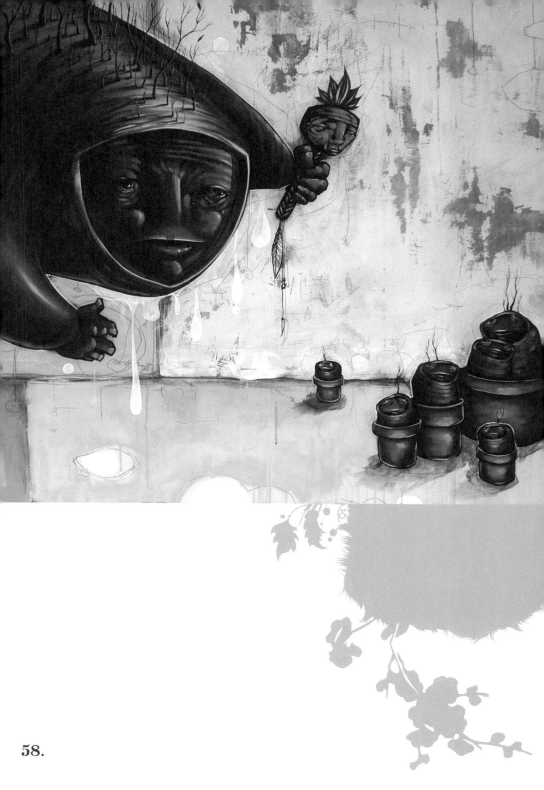

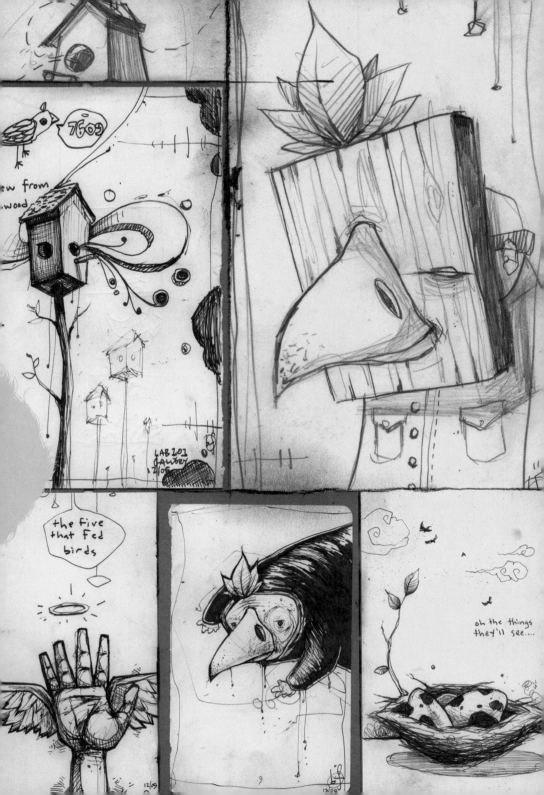

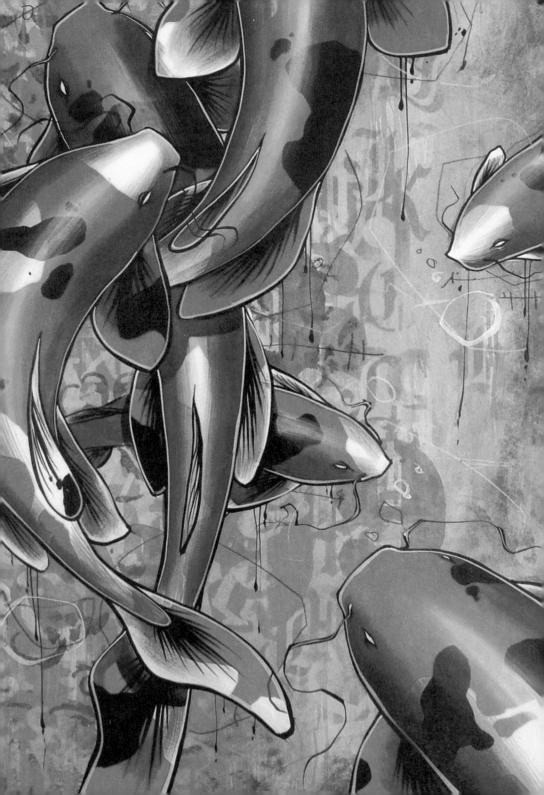

of Flora
Fauna

2008

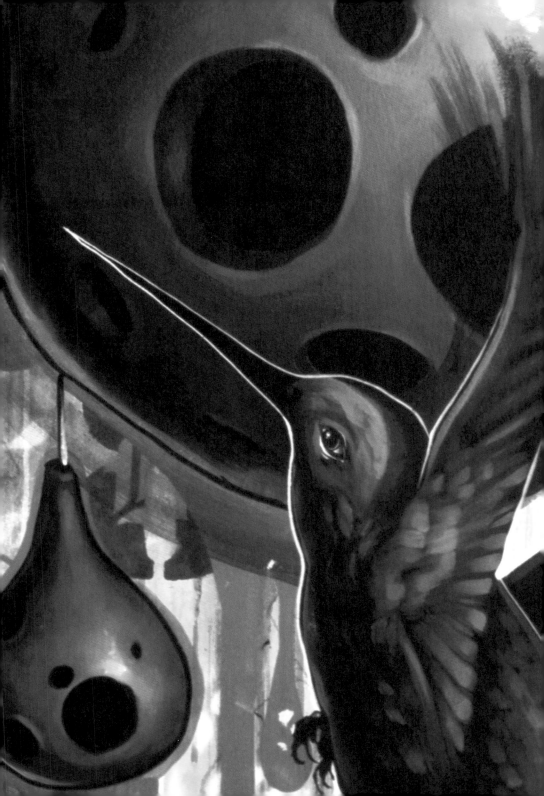

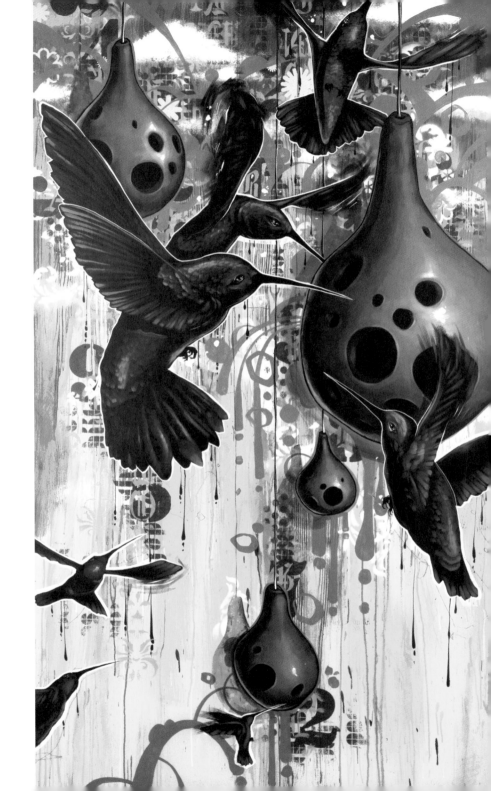

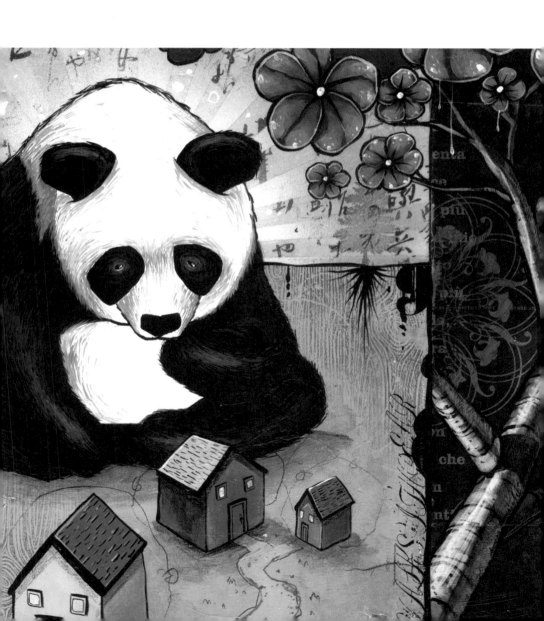

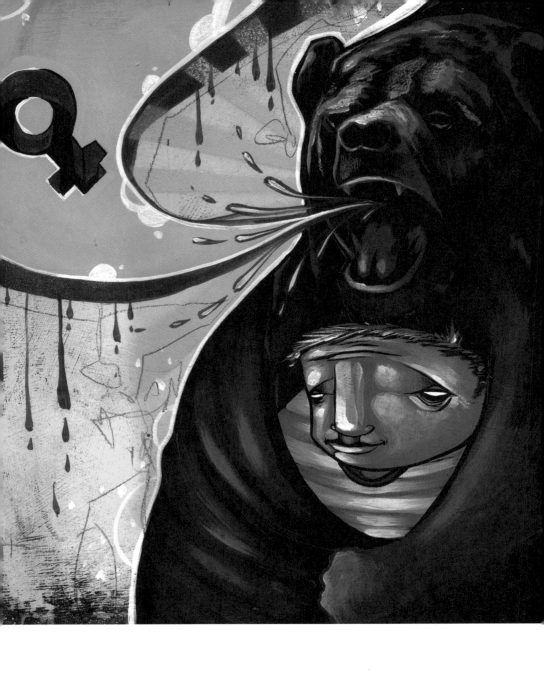

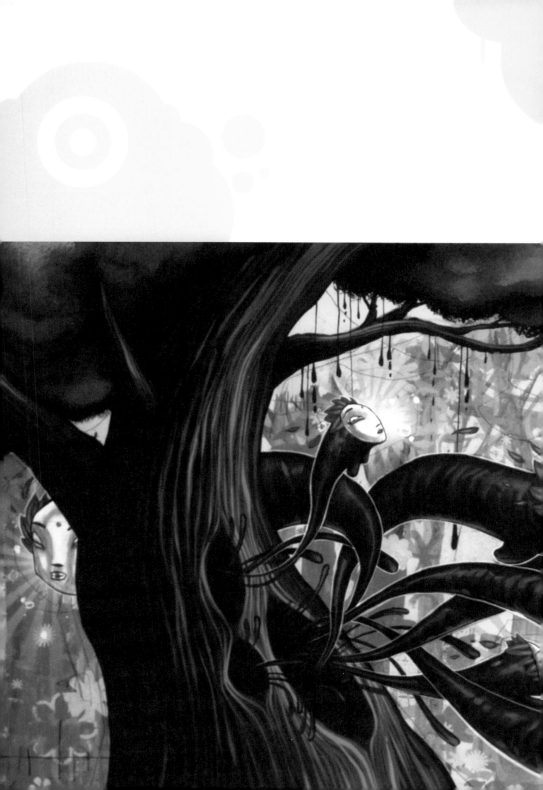

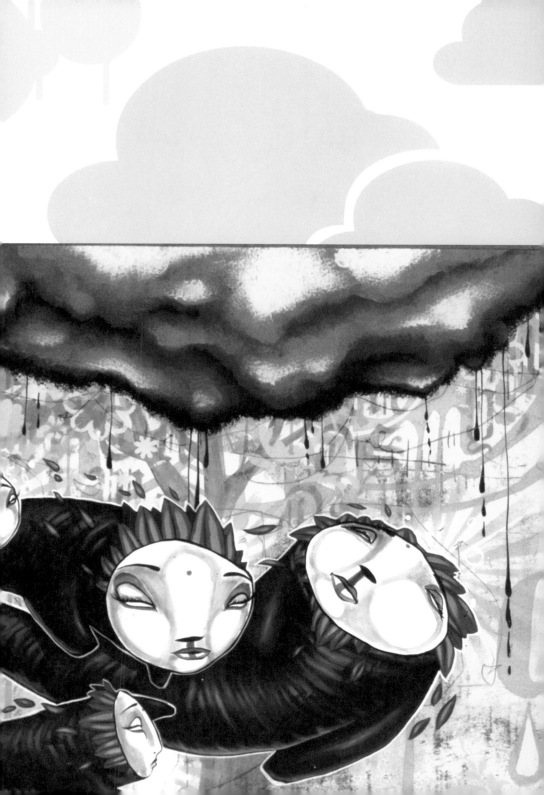

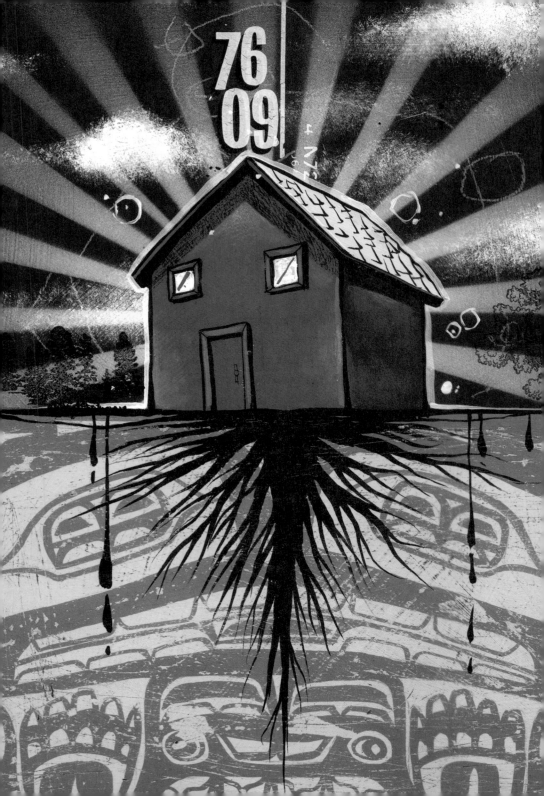

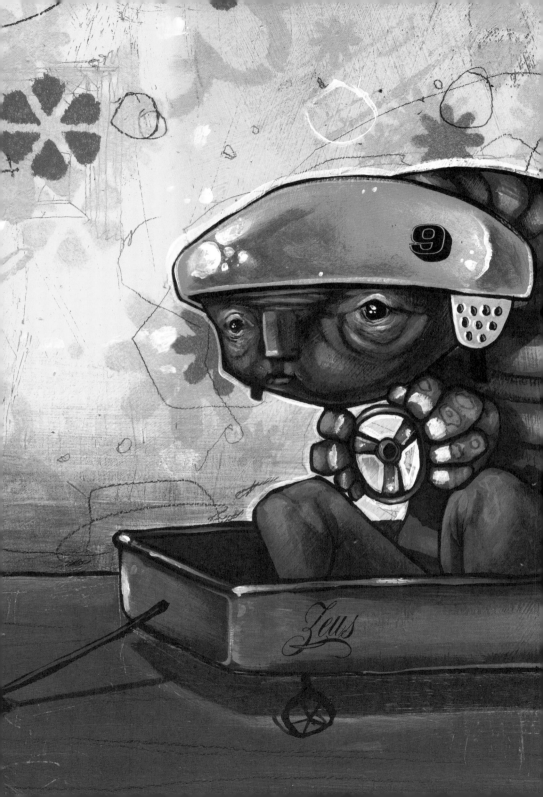

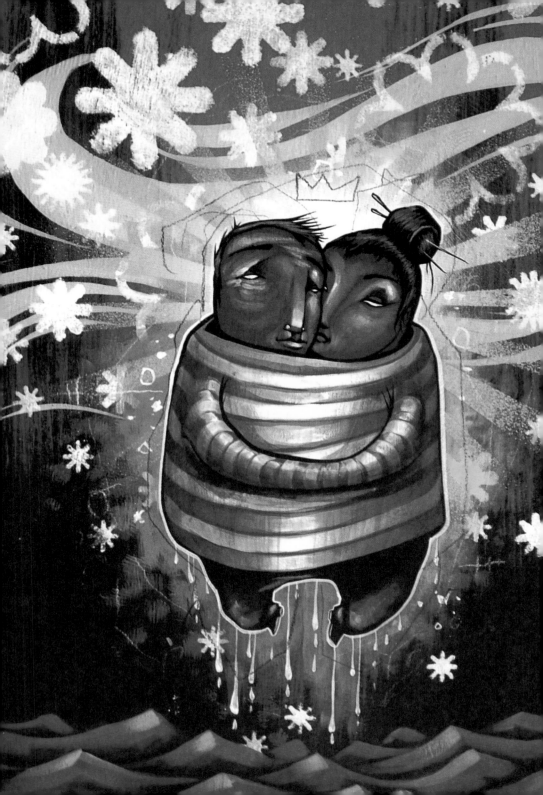

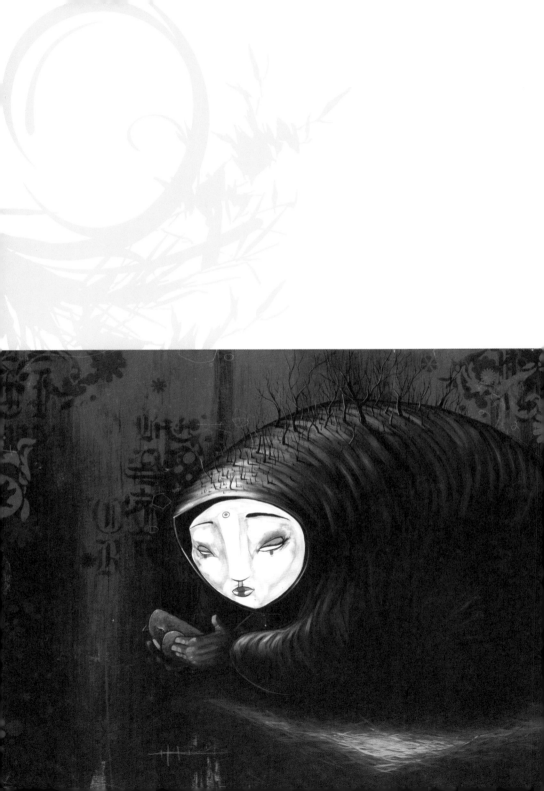

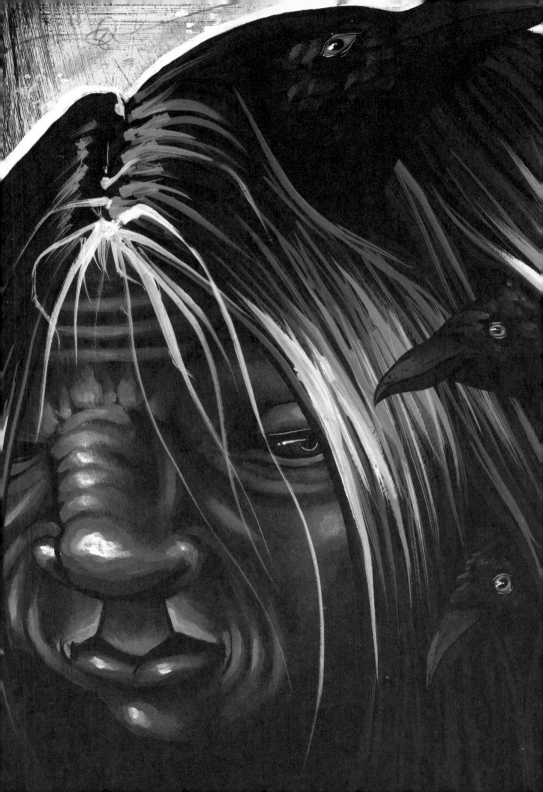

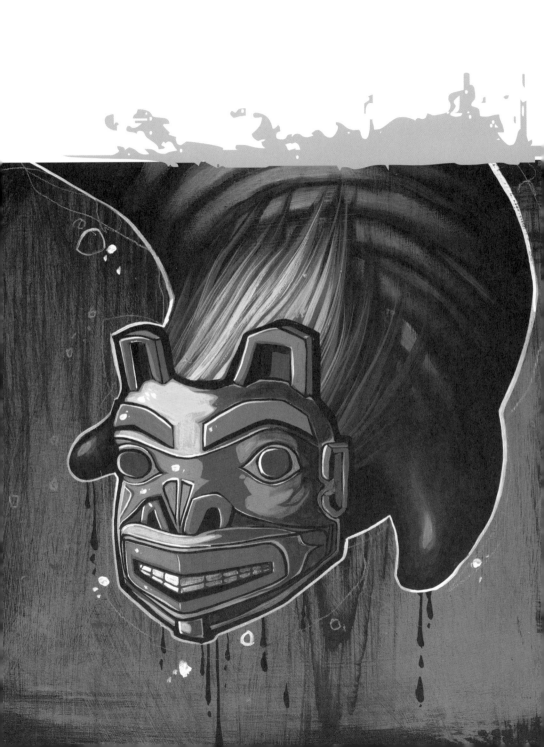

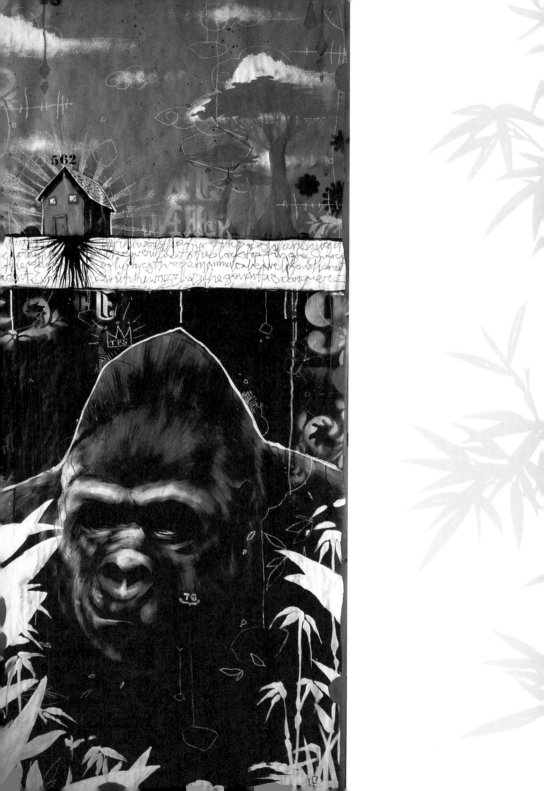

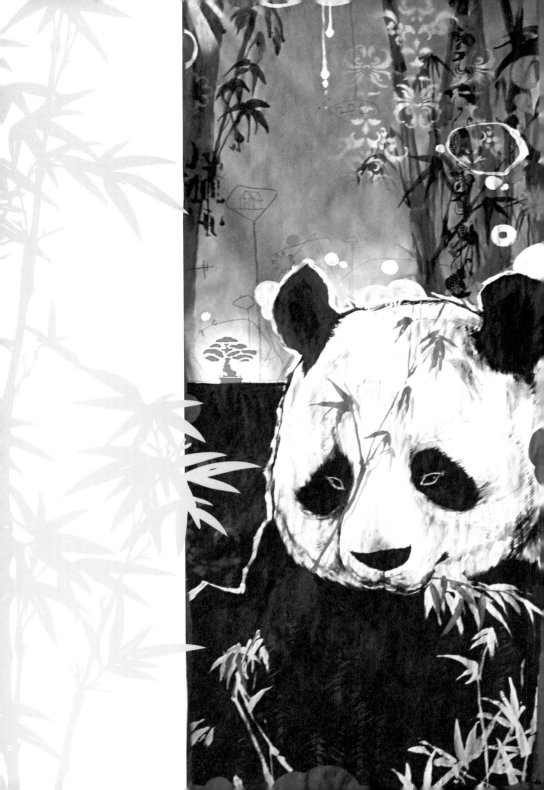

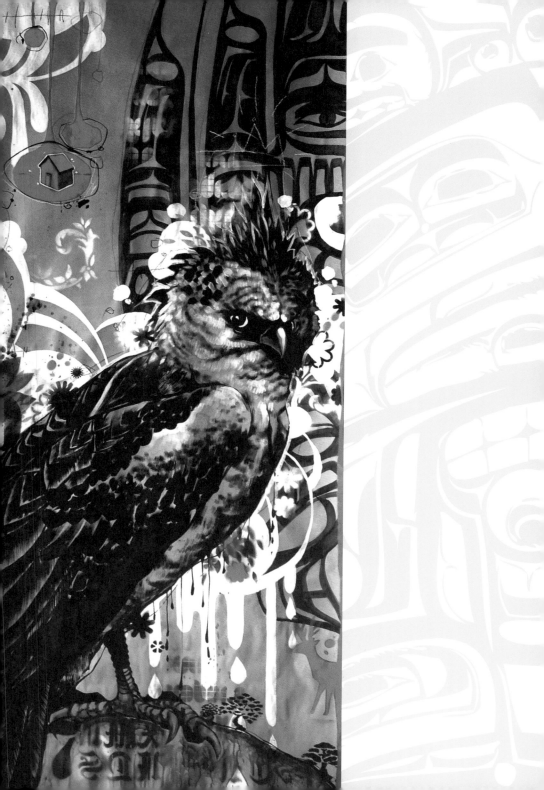

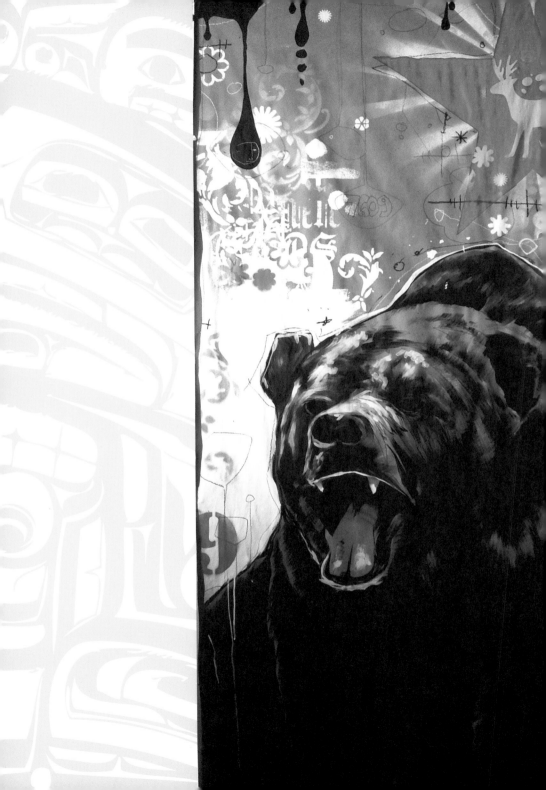

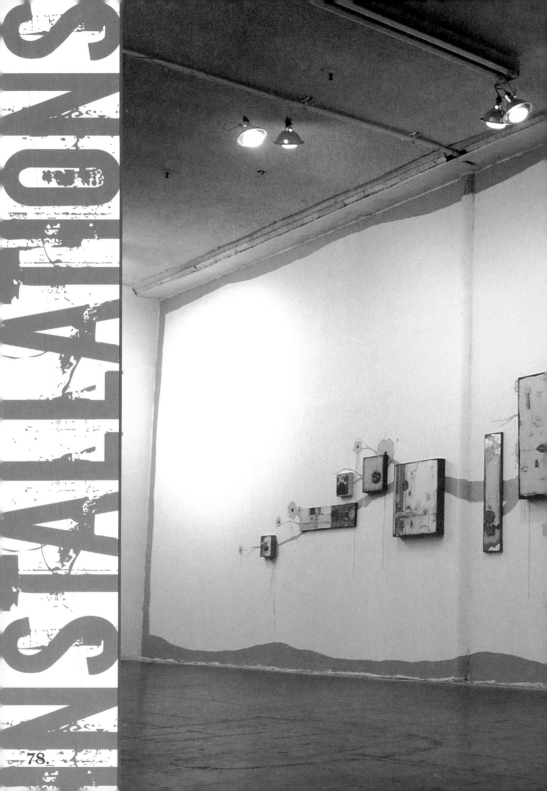

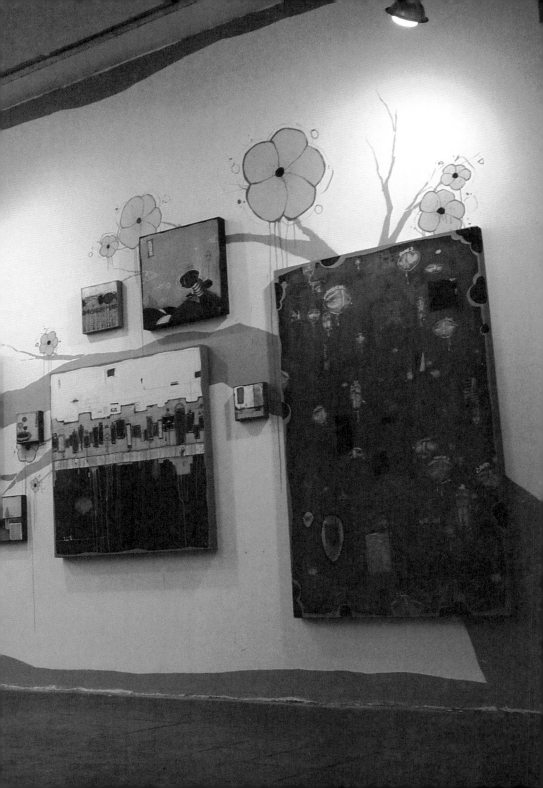

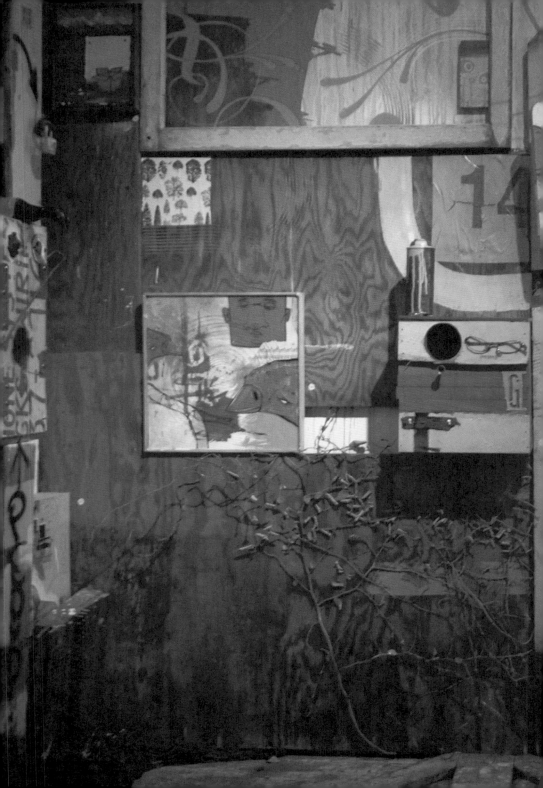

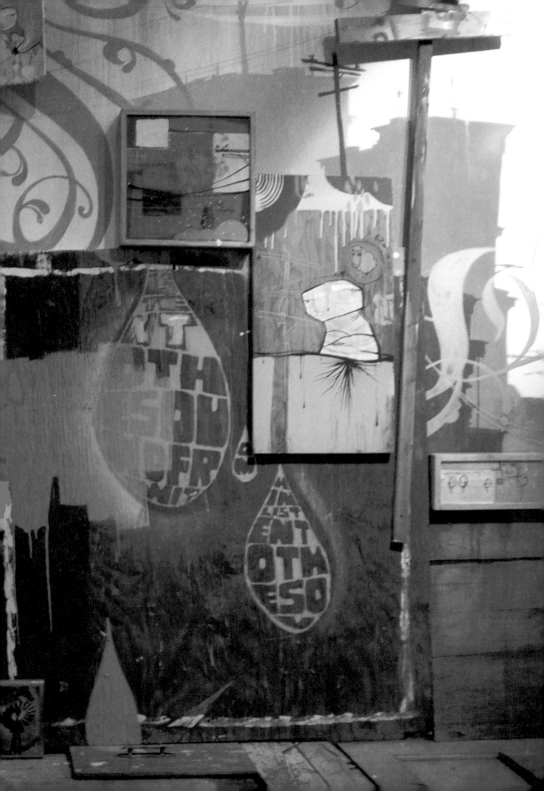

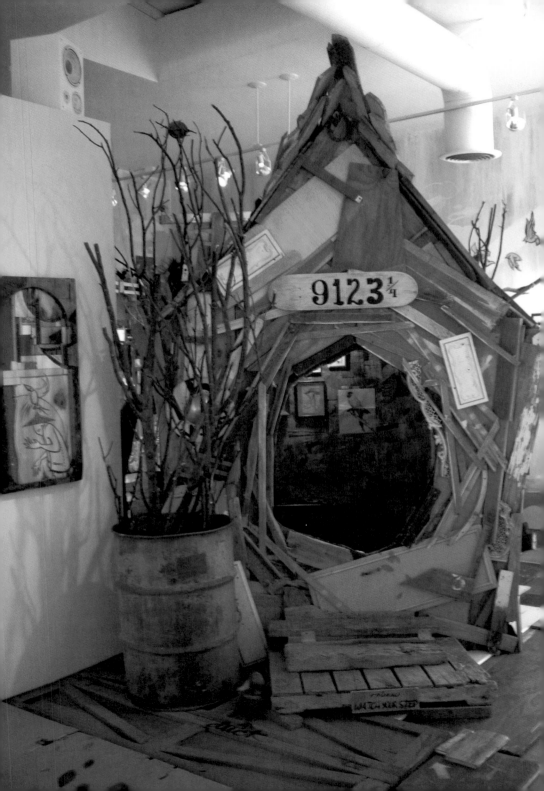

912 3¼

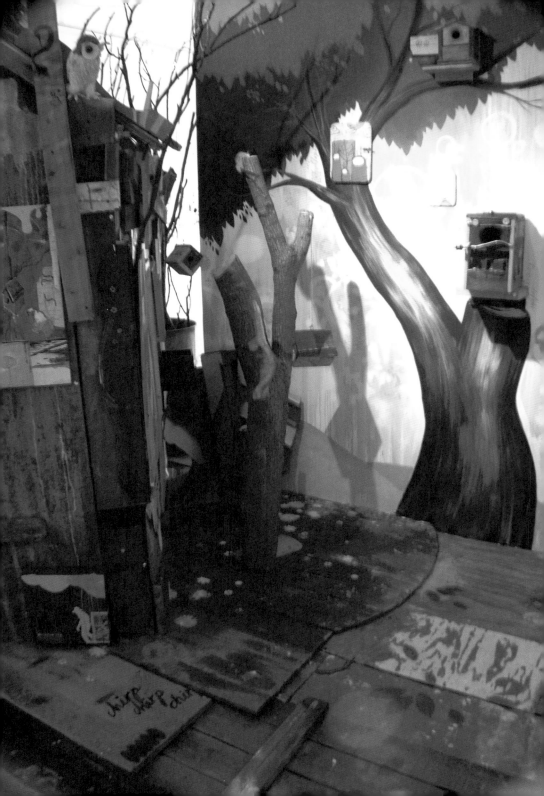

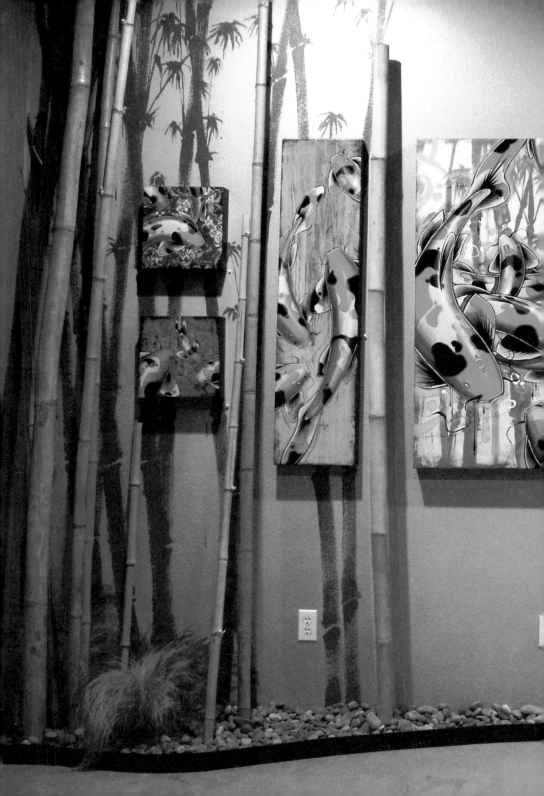

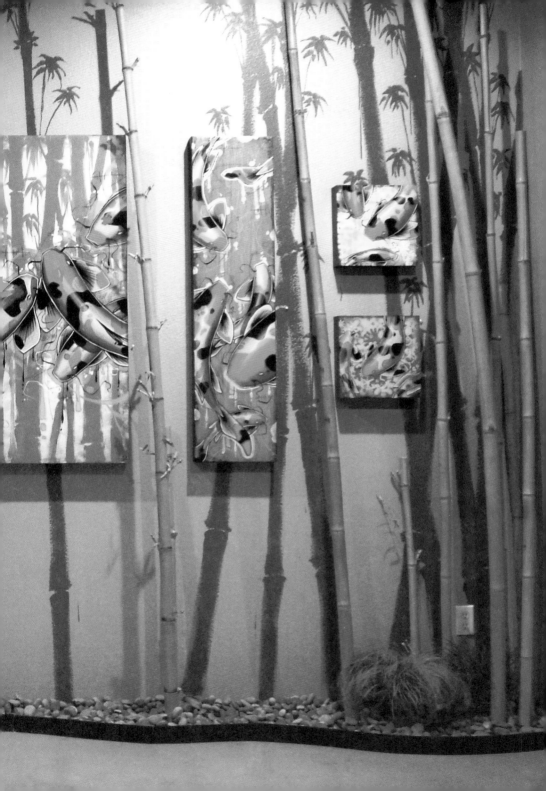

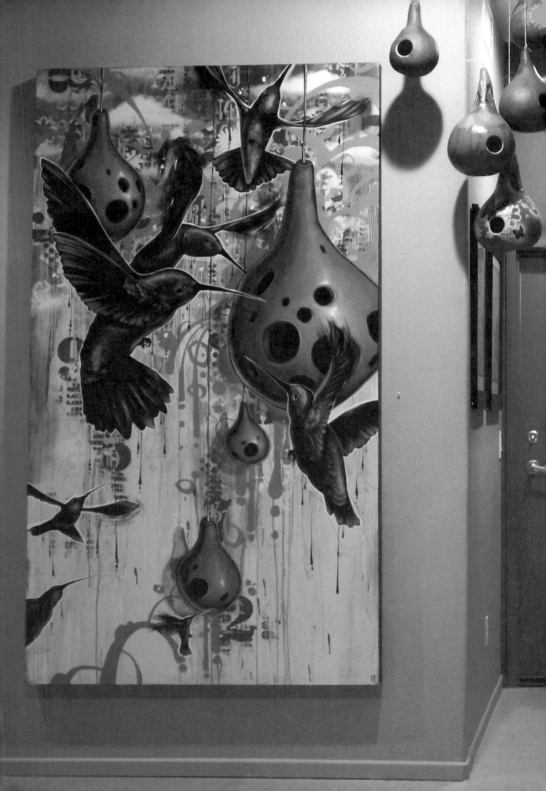

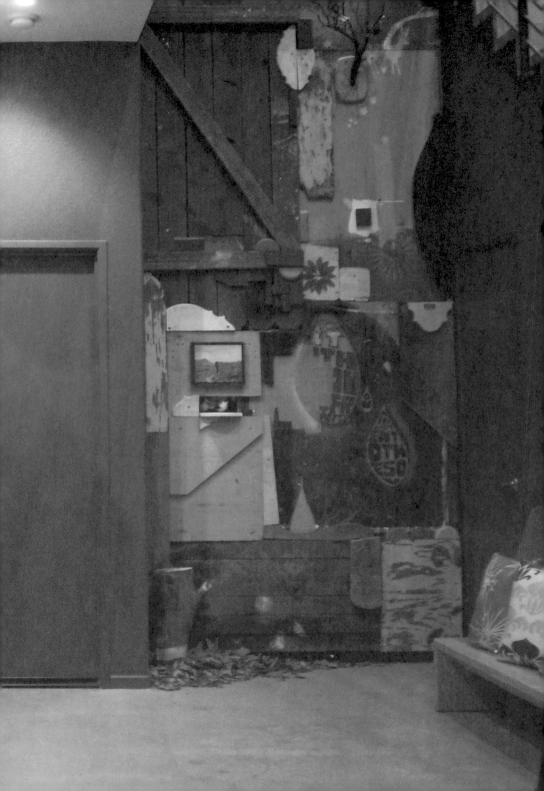

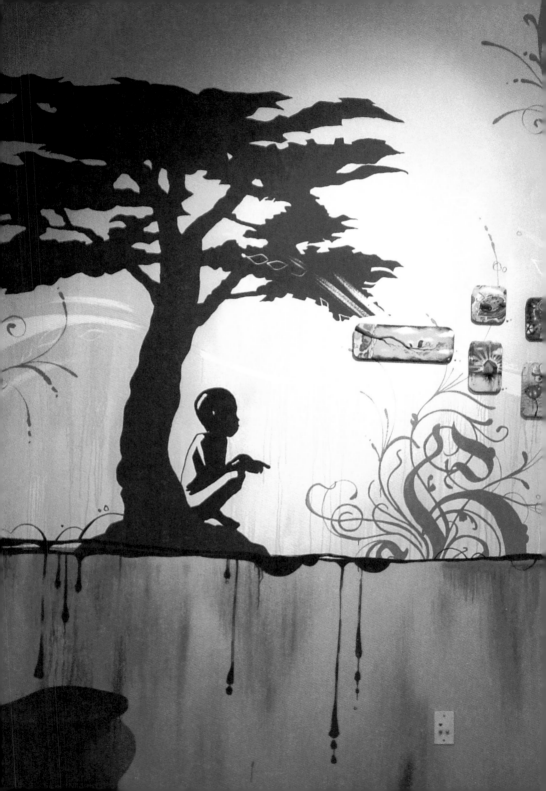

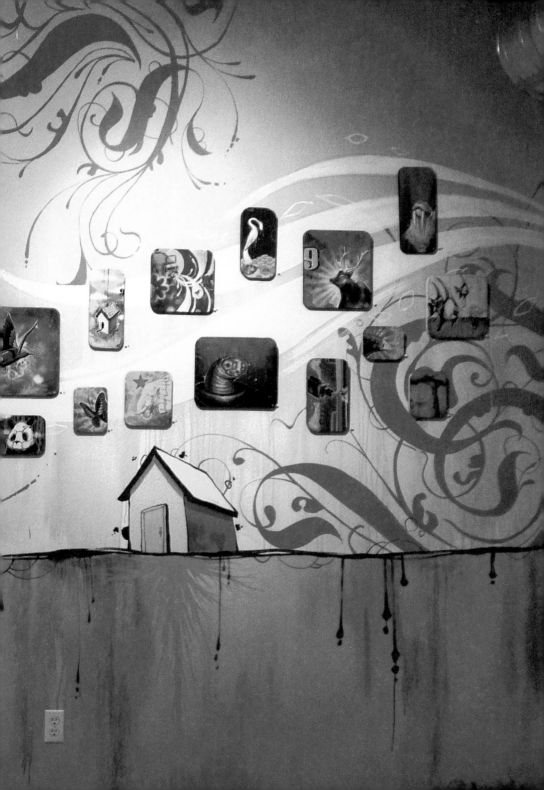

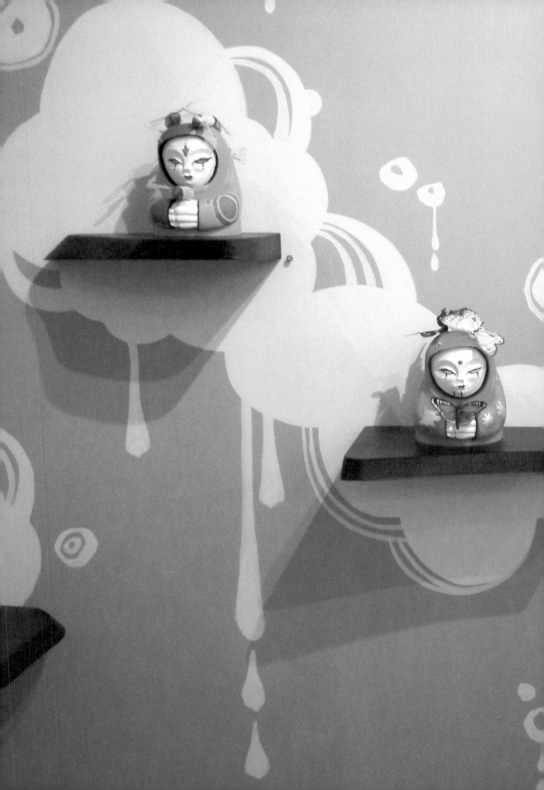

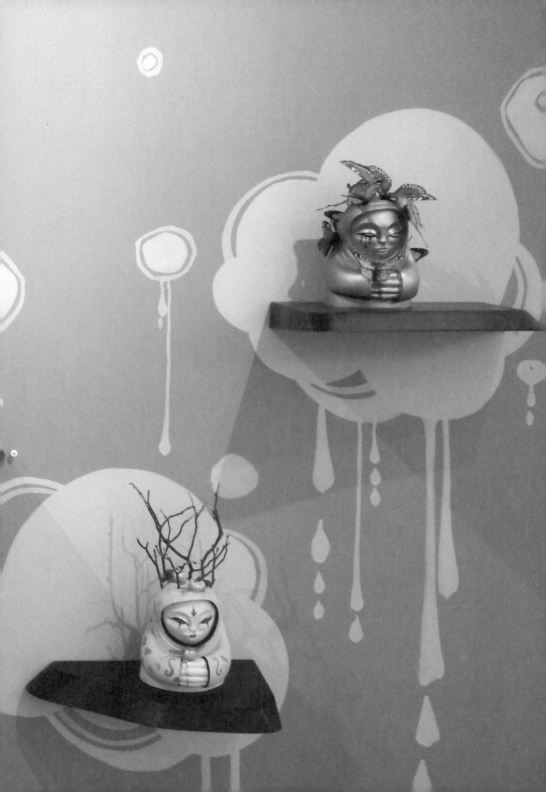

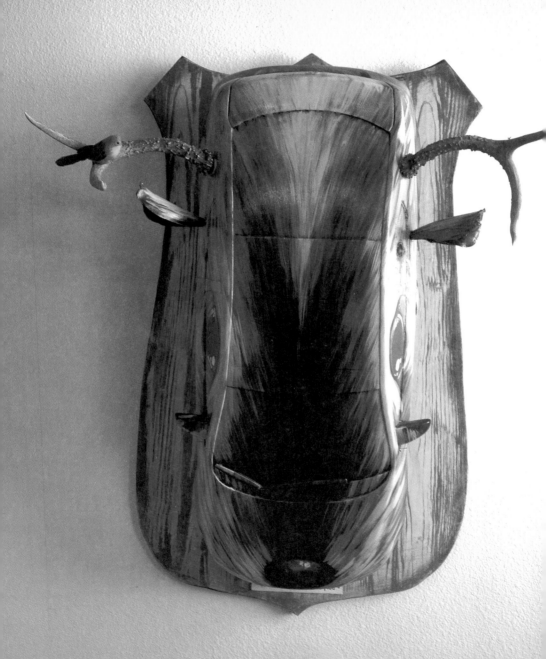

90.

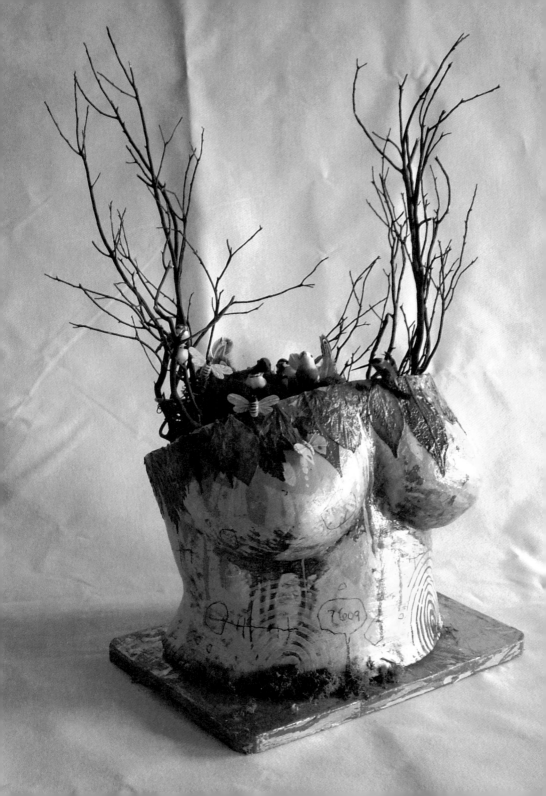

THE ITEMS

I AM WHO I AM BECAUSE OF...

My supportive and loving family, Mom, Pop, Brandon, Lara, Poppa & Grandnan & the Hogg family, Grandma and Grandpa. Eugenie, who loved me before this all started and who makes it possible for tomorrow. Matt & Ben at Upper Playground who were the first to believe in this project. Josh Clay and Michelle Reitblat, thank you for your selflessness and dedicated time to my studio. L.C. and Michelle Waterman, you popped my virgin feeling of recognition. Michelle Berc, Jensen & Katie, Maesa & Bradi, Blue Bottle Art, Pr1mary Space, ABOUND, Skeleton Art, DRIFTER & Long Beach East Village Arts District, you all were the first believers. Jen McClean, for completing my first art sale. Nathan Ota & Nick Taggart, your talents and teachings are imprinted in every stroke I do. My supportive galleries, Lineage, Scribble Theory, Lab 101, & Distinction. Jen Gilbert, for helping me unwind. Daniel Garcia, who fathered the Nestkeeper from 2D to 3D. All you art dorks, Erik Otto, Freddi C, Tim McCormick, James Naccarato, Jophen Stein, Josh Krause, Amy Duran, Sage Vaughn, Sam Flores, Oliver Vernon, Chris Silva, Ekundayo, Bob Dob Jason Mahoney, Aaron Kraten, Audrey Kawasaki, Silvia Ji, Joe Ledbetter, Thomas Hahn, Randy Noborikawa, Mathew Curry, Lesley Reppeteaux, Tra Selthrow, Wilson Hsu, Kathie Olivas, Brani Milne, Greg Simkins, Omar Lee, 7teen, Jeremy Fish, Damon Soule, Ben Tour, Andy Goldsworthy, Hayao Miyazaki, Robert Rauschenberg, & Jean Michelle-Basquiat.

Oh, and my dog Zeus, the ninja ridgeback brown of Long Beach.

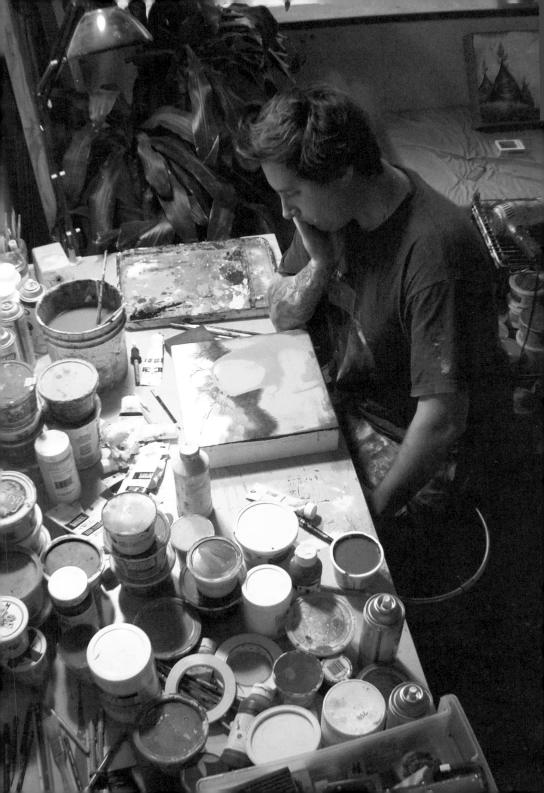